Remembering Champaign County

Remembering Champaign County

Dannel McCollum

Charleston · London

THE
History
PRESS

Published by The History Press
Charleston, SC 29403
www.historypress.net

Front and back cover images: *Courtesy* History of Champaign County, 1878, *Champaign County Archives of the Urbana Free Library, the author and* News-Gazette.

First published 2010

Manufactured in the United States

ISBN 978.1.59629.963.4

Library of Congress Cataloging-in-Publication Data

McCollum, Dannel Angus.
Remembering Champaign County / Dannel McCollum.
p. cm.
Includes bibliographical references.
ISBN 978-1-59629-963-4
1. Champaign County (Ill.)--History. 2. Champaign County (Ill.)--Biography. I. Title.
F547.C4M44 2010
977.3'66--dc22
2010023670

Contents

CONTENTS

CONTENTS

Acknowledgements

I t was the late Richard L. Cannon, a close friend for forty-four years, who first stoked my interest in local history. I am particularly grateful for the collections and personnel of the Champaign County Archives of the Urbana Free Library, which represent the bedrock for any serious effort to delve into the county's past. All references to archives refer to this outstanding resource. I give a special thanks to Anke Voss, archivist. For these stories, I am also deeply indebted to the scores of fascinating people whom I have interviewed over the past forty years. And—without question—this book would not have been possible without the contributions of my wife, Jeanette, whose encouragement, advice and editing have been crucial.

Introduction

A Personal Perspective on Champaign County Stories

As host to a great university, Champaign County attracts people from everywhere. I cannot help but be struck by how many newcomers comment on the monotony of the flat to gently rolling landscape. Even among the local population, many fail to appreciate the land and the history of the county in which they were born and raised. But what else could one expect from an area bulldozed over by a series of massive, continental glaciers over tens of thousands of years ago? When these ice sheets reached east-central Illinois, they overrode the valley of a large river, filling the lowest areas with sand and gravel. The last ice sheet, the Wisconsian, retreated to the north a little more than twelve thousand years ago (during this period of global warming, the rate of glacial melt exceeded the rate of advance). In spite of the monotonous landscape—and in some cases because of it—it would be a serious mistake to think that there is nothing to be learned of this place.

The ice left in the form of melt water. The solid material accumulated by the ice as it had traveled south from Canada and not borne away by the melt water was left. This amounted to several hundred feet of everything from talcum-sized particles to boulders the size of automobiles. No visible trace of the ancient river remained. The resulting landscape was poorly drained and littered with ponds and swamps in low-lying areas. Displacing the ice was a succession of plants, dominated by tall grasses with the most spectacular being big bluestem, which could reach a height of seven to eight feet. This plant mix, rolling across the relatively flat landscape with its broad vistas, came to be known as prairie.

During the spring, before the tall grasses could take over, the prairie was awash with color from a multitude of flowering plants. The only breaks were the scattered timber belts and groves that lay along streams or to the east of ponds and swamps. These woody growths depended upon the fire breaks provided by places where there was standing or moving water. All that was required were the dry grasses and a spark in the fall and winter for great fires to be driven across the area by weather systems from the southwest. The transition to the great timberlands began just to the east in neighboring Vermilion County and stretched with only occasional breaks to the eastern seaboard. During the thousands of years that followed the glaciers, the dense grasses and other prairie plants built up a layer of organic-rich top soil, in places up to a depth of four feet and more.

Into this environment moved the Native Americans, known since the time of Columbus as Indians. During the period of their exclusive occupancy, these first humans lived almost totally off the renewable resources of the land. They traversed and hunted on the prairies, but they kept largely to the scattered groves and timber belts that provided wood for fuel, shelter and tools. Although possibly responsible for the elimination of some of the larger game animals such as bison that once frequented the area, they left the rich top soil undisturbed; there were virtually no permanent marks upon the landscape from their presence. The most common material artifacts that survive from their occupation are occasional stone implements plowed up by farmers.

Though born and raised in Champaign County, I was the product of imports attracted to the University of Illinois. But, in living in the county for virtually all of my seventy-two years, I had the good fortune to meet descendants of pioneers who dated back to the first European American arrivals, especially those of the Busey, Sadorus and Harris families. Most notable have been Garreta Busey, Chester Sadorus, Julia Harris Dodds and her niece, Melissa Dobbins Chambers. Garretta was a direct descendent of Matthew Wales Busey, through Simeon H. Busey and George W. Busey; Chester was the great-grandson of Henry Sadorus; and Julia and Melissa descended from Benjamin Franklin Harris. These associations have been important to the personal attachment that I have developed with the county over the years.

Chapter 1
Arrival of the European Americans

THE PIONEERS

Beginning in the early 1800s, great changes came to the prairie. The European Americans brought a lifestyle that was totally incompatible with that of the aboriginal inhabitants. In the span of 250 years, like a great plague, they spread across the North American continent from east to west. Their predisposition was to occupy and subdue the land. The natives begrudgingly gave way to the newcomers, victims to previously unknown diseases and to disunity among the numerous tribes as well as to the advanced organization and technology of the whites.

Most of the newcomers entered into east-central Illinois from the upper south. A minority struggled through the forests of the lower Old Northwest; they were known as Yankees. Their meager possessions were limited to what they could transport through the wilderness. Household goods might include a few kitchen items for the women, and axes, firearms and knives for the men. They had to make virtually everything else. Accustomed to the forest environment, they were used to the resources offered by the timber. The forests offered wood for housing, fuel, tools and fencing—all found in the timber groves. The prairies offered none of these essential resources.

While the natives did cultivate corn and other plants on a small scale, the European Americans were serious farmers. They quickly discovered that the tangled root mess of the tough prairie grasses did not give way easily to the plow, especially to their primitive plows with wooden moldboards. It was said that it was cheaper to buy the prairie than to have it broken. Thus, those

early pioneers found it was easier to girdle trees and plow around the stumps in timbered areas than to fight the prairies.

Early Vermilion County historian Hiram Beckwith noted, "The early settlers clung to the timber; they did not expect or believe the prairies ever would or could be settled." The sentiment was echoed by J.S. Lothrop, Champaign County's first historian: "The earlier settlers regarded the prairie as wholly unfit to live upon, and that he who would venture to live there was a fool or insane." The prairies were not without their value. Being largely unoccupied and flush with grasses, they provided free grazing at the expense of Uncle Sam. Cattlemen thrived in those early days.

THE FIRST PERMANENT SETTLERS

Henry Sadorus and Family

Though other whites had arrived in this area prior to Henry Sadorus, he is credited as being the first permanent settler in what was to become Champaign County. Henry also had the company of his wife, Mary, and their children; male historians sometimes tend to forget to mention the ladies. The Sadorus family arrived in 1824, establishing itself in a small grove of trees along the Okaw or Kaskaskia River in the southwestern corner of what became Champaign County. The United States government had already converted the lands in the area—which it had acquired from the natives by hook and crook—into real estate through its land surveys. Henry took advantage of the bargain price of $1.25 an acre. After many earlier travels, he was done moving.

When J.S. Lothrop published his history of the county in 1870–71, he included an account related by the old pioneer about his adventure of taking a load of grain to a mill in Eugene, which is just east across the state line in Indiana, in December 1830. The straight-line distance between Sadorus Grove and Eugene was about fifty miles. It was a tale worthy of Jack London, so gripping that it was reprinted in the 1878 county history as well as in J.O. Cunningham's history of 1905. I also included a somewhat rewritten version in *Essays on the Historical Geography of Champaign County.* In much abbreviated form, here is what happened:

Sadorus headed out in somewhat mild conditions with his Virginia wagon with two yoke of oxen. He arrived at the mill in Eugene on the Big Vermilion River only to discover that a hard freeze had made the plank road down the

bluff a frozen sheet of ice. Realizing the risks but with no other choice, he drove his team forward only to have it slide down the hill in the "fastest descent ever." It took help from the mill to right his wagon and reload it with his scattered load. Sadorus headed home after a day at the mill, waiting for his grain to be ground.

Encountering some initial difficulties crossing a partially frozen creek, Sadorus stopped at the cabin of another settler for the night. Also there was a "mover" and his family. They had been advised to wait and travel with Sadorus, as winter travel could be dangerous and on occasion lethal. This proved to be excellent advice for this particular person. The following morning Sadorus and the party set off. Overnight, the weather had become intensely cold, as people familiar with midwestern winters can attest. The travelers made it as far as Hickory Grove, which stood just east of the present-day village of St. Joseph. While the party suffered severely from the cold, they survived the night.

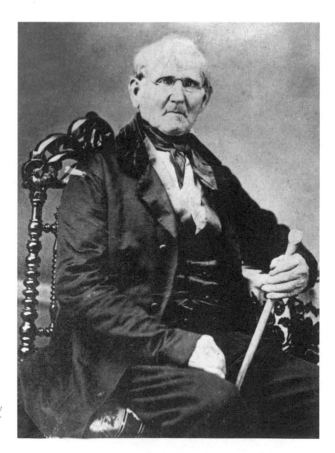

A photo of Henry Sadorus in old age. *Courtesy Champaign County Archives of the Urbana Free Library.*

The next morning, Sadorus advised that they stay at the grove and await better weather; the mover insisted that they go on. So, over the frozen and unforgiving ground, the group set out with the family huddled against the cold in their wagon. It took the entire day to travel the twelve miles southwest across the prairie to the shelter of Lynn Grove. But the mere shelter of the grove was not enough—it was a fire or freeze. Sadorus was so chilled that he initially was unable to get a fire going with his flint and steel; his hands refused to work. Finally, after stomping his feet and rubbing his hands together with great vigor—in a final, heroic effort—he was able to strike a spark that ignited the "punk" and, in turn, the tinder he had assembled.

The mover, in an effort to help, began pouring some powder from his horn into the tiny fire. The inevitable result was that the flame traveled up the stream of powder, causing the contents of the horn to explode and scattering the small fire. It was only with the greatest difficulty that Sadorus was able to reassemble the fire and prevent the party from freezing. Such were the perils of travel in those pioneer times. The following day, under moderating conditions, the party reached Sadorus Grove; the mover and his family had dodged a bullet. Without the help of Sadorus, the family might well have joined the human remains later found in several of the groves in the area.

THE SADORUS LEGACY

Henry Sadorus died in 1878. In his long life, he had seen the wilderness of the Illinois territory transform into a patchwork of prairie farms. When the Great Western Railroad came through the Sadorus farm in 1855, the station and the village that followed were named for the family. On the Sadorus farm was a huge boulder composed of a granitic gneiss intruded with igneous veins. It was indeed a well-traveled rock, having been wrenched free by the glaciers from possibly as far north as Canada before it was deposited on the land Henry came to own. In 1930, the rock was moved over a mile to the east by three large steam engines; it broke into several parts in the process. Reassembled, there it sat at the intersection of a county highway and a township road. In yet another move, the rock in 2002 was again disturbed and moved into a park in the village of Sadorus where it serves as a memorial to the old pioneer.

In the late 1930s, my family lived next door to Chester Sadorus, a direct descendant of Henry. I remember being regaled with stories of the pioneer

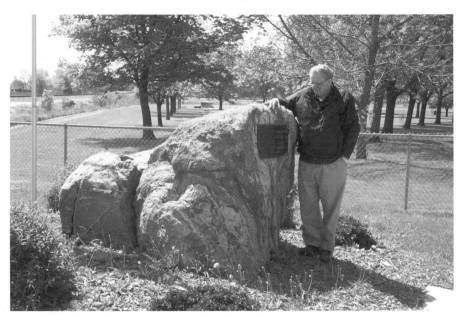

Sadorus Rock with geologist and history buff Dwain Berggren. *Courtesy the author.*

days, as handed down in the family. Retained in their possession were fascinating artifacts that included Old Henry's gold-capped cane, a boot jack and—most exciting of all—the plains rifle and powder horn that belonged to Henry's son, Henry Titus Sadorus. The gun and horn were left to me and remain cherished possessions to this day.

A Long-Lost Mill Site

I have long had a fascination with water mills. It could date from a class trip to New Salem State Park while in elementary school. There, the class toured the rebuilt Rutledge Mill on the Sangamon River. During the seventies and eighties, as an avid canoeist in local rivers I made a point of locating long-gone mill sites. There were two reported as being on the Salt Fork River in Champaign County, both built during the early 1830s: Moses Thomas at the site of Old Homer and George Akers. The former mill operated for many years and later became a regional recreational site focusing around the rebuilt mill dam. There was no problem knowing where that mill was located.

That wasn't so with the George Akers mill; because of its short life, it rated only brief mention in the early histories. Other than being in Sidney Township and on the Salt Fork, no other location information was provided. Its short life is understandable, with such enterprises being highly vulnerable to high water and fires, especially the former.

On one of my early trips on the Salt Fork downstream from Sidney, in especially low water, I noticed logs or heavy timbers in the bottom of the river with the appearance of having been placed there. Wood consistently submerged is usually highly resistant to decay. Subsequently, I became acquainted with Ruby Rogers West. Ruby, who was ninety-two when we met, was mentioned to me as having been a teacher in one-room schools during the earlier years of the twentieth century.

There was a bit of serendipity involved when I learned that she had been married into the family of James Michael West, whose farm was situated in Section Two of Sidney Township. The farm also spanned the river where I had noticed the timbers. As a young matron living on the farm, she too had noticed the timbers and had asked her father-in-law about them. West said when he came to the area in 1854, the remains of an old mill stood by the river. That information was sufficient to send me to the early land records where I found that George Akers had entered land in that exact location in the 1830s. His long-lost mill site had been rediscovered.

ENTREPRENEUR EXTRAORDINAIRE

Benjamin Franklin Harris

My earliest connection with the Harris family dates back to my grade school years; of my schoolmates—unbeknownst to me at the time—was a great-great-grandson of this venerable pioneer. A second connection occurred somewhat later. On Saturday mornings as a young teenager, my mother would drive my brothers and me downtown to change money, looking for the coins missing from our various collections. Our preferred bank was the First National Bank of Champaign, at the time the big bank in the community. And big it was: a five-story classic revival structure with a grand lobby. It was Frank's bank.

B.F., aided by his phenomenal memory, wrote his remarkable story out by hand—some three hundred pages—late in his long life (1811–1905) at the request of his grandson, Benjamin Franklin Harris II. The account remains

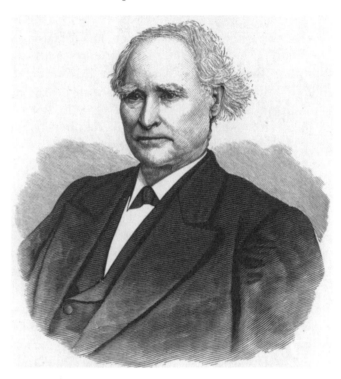

B.F. Harris, engraving
in *History of Champaign
County, 1878.*

the best and most complete account left by any of the early pioneers. While
B.F.'s connection with east-central Illinois did not occur until some two years
after the county was formed, he became a towering figure in the new county
in very short order.

B.F. "Frank" Harris, the cattleman of cattlemen in east-central Illinois,
was born in Virginia. In 1816, encouraged by the boom years following the
War of 1812, his father, William Hickman Harris, purchased a 250-acre
farm in that state, paying the princely sum of $64 per acre. With only $2,000
upfront, the farm incurred considerable debt. In the 1820s, according to
B.F., his father "was a Democrat and a great Jackson man." During Andrew
Jackson's first term, the country was prosperous with a "sound and good
currency in the United States bank and its branches." Jackson's veto of the
renewal of the bank's charter eliminated the sound currency and promoted
the Panic of 1837. B.F.'s account continues: "My father was no longer a
Democrat nor a Jackson man; [he] joined the old Whig party and afterwards
was a Republican and [was] down on Democracy."

In 1827, in bad economic times and a collapse of land values, his father was
burdened under a huge debt. To help out, young Frank, at sixteen, and his

brother engaged in a long-haul freight business using the family's teams and wagons. This involved hauls to places as far apart as Baltimore, Maryland; Nashville, Tennessee; and Wheeling, at the time a part of Virginia. On one of those trips, the young man met up with President Jackson, returning to Washington, D.C., from a visit to his home in Tennessee. It took four years of these hauls to help his father eliminate the debt and sell his farm at little more than a third of what he had paid for it. Out of debt, the family headed west to Ohio. B.F. stayed with the family for one year, which was long enough to help his father become established on a new farm.

A life-changing opportunity came along for the young man. He was hired on a cattle drive from Ohio to eastern Pennsylvania. The drive involved swimming the herd across the Ohio River, crossing the Alleghany Mountains and fording the Susquehanna River. Arriving at the destination, B.F. continued in the employment of the drovers to help market the cattle. For the most part, the cattle were sold to others to be fattened up for eastern markets. While there, he helped market two more droves of cattle. Being a quick study and having saved some money in his earlier years, he resolved to go into business for himself. Back in Ohio, he assembled his own herd and set off to the east as his own boss. Even with challenging circumstances, he still made a profit.

Based upon this success, B.F. headed for Illinois in June 1835 with $4,000, three-fourths of it borrowed, to assemble yet another herd. That represented a huge amount of money for the time and a considerable risk. It was his first contact with Champaign County and the surrounding area and prompted his first purchase of land. After several close calls with would-be robbers, he assembled his herd and drove them to eastern Pennsylvania for yet another profit. B.F. did yet another drive east. On assembling his third herd in Illinois, he became quite ill with typhoid fever. Recovering, Harris found his cattle had been well cared for. Buying still more, he had 430 head altogether. He turned them out on the prairie to graze where they fattened up on the thousands of acres of unsold government land. At that time, grazing cattle was all the early settlers thought the prairie was good for. This was to be his last trip east with cattle. It was eventful because he met his first wife, Elizabeth Sage, and married her at the home of her sister.

On his return, he stopped to visit his father, who tried to persuade B.F. to buy a farm nearby. In spite of the profitable cattle drives, this would have put Harris in debt; it was a circumstance he did not find attractive because he remembered his father's earlier experience in Virginia. It was more appealing to the newlyweds to continue on to Illinois to buy over twice the

acreage and have money left over. The land was located on the Sangamon River southwest of Mahomet and was to become the nucleus of the more than five-thousand-acre spread that he eventually acquired.

After one final cattle drive to St. Louis, his days in that business were over. B.F. was quick to realize a much more profitable way to earn money in the cattle business. Recognizing that there was no good method to ship out the corn he produced, instead of driving cattle to eastern markets for others to fatten up, B.F. used the corn produced on his growing farm plus what he could buy from neighbors and fattened the cattle up on his own spread. He then had them driven north to Chicago, sending his corn out on the hoof. In the early 1850s, a young Samuel Allerton was in the neighborhood to buy hogs. Finding that the prices were higher than he could afford, B.F. allowed him to take his hogs on consignment and pay later. This act gave Allerton a start on his rise to become a major player in the Chicago stockyards and later develop a very large spread of his own in neighboring Piatt County.

Given the bank disaster occasioned by Andrew Jackson, B.F., like his father, had become a solid Whig and changed in the 1850s to the Republican Party. As a prominent Whig/Republican, he was, of course, a friend and supporter of the sixteenth president. In 1861, shortly after Abraham Lincoln's inauguration, B.F. visited Washington and paid a call at

First National Bank of Champaign is a testimony to B.F. Harris's legacy. It was built after his death. *Courtesy the author.*

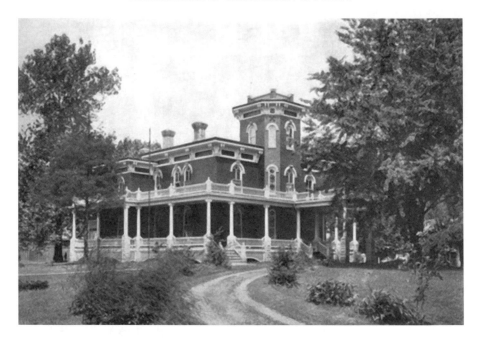

The J.P. White/B.F. Harris House on Church Street. *Courtesy Melissa Chambers.*

the White House. It was a trying time for Lincoln with the succession of the southern states and the death of Colonel Elmer Elsworth, which occurred during the visit.

B.F. moved from the farm to the city of Champaign in 1862, purchasing the finest house there, the J.P. White house. It was a large Italianate, two-story brick structure standing alone on the 500 block on Church Street. The house is long gone, and the block is now occupied by the Champaign YMCA. By 1865, Harris, while continuing his farming and livestock interests, had become involved in real estate and other business ventures in Champaign. This required a sound bank, which B.F. and other businessmen proceeded to establish—the First National Bank of Champaign. One of the other organizers was Simeon H. Busey. Busey did not remain with the bank for long; with his brother, Samuel T. Busey, recently returned from service in the American Civil War, he organized the Busey Brothers Bank in Urbana. As he did with many of the other organizers as they dropped out, B.F. acquired their stock as well.

In spite of his new focus on business affairs in Champaign, Frank Harris never lost the attachment with his rural roots. He continued to take an active interest in the livestock business, keeping up his account books to the end of

his long life. Taking great pride, his corn-fed cattle consistently bested the competition in well-publicized weigh-ins in Chicago.

B.F. Harris came to Champaign County at a time when fortunes were easily won and lost often through exploitation, speculation or luck. With B.F., there was no exploitation. He was a shrewd observer and saw opportunities when they appeared. Instead of idle speculation, he threw himself into his ventures, which in the early days included cattle drives of over seven hundred miles crossing such formidable obstacles as the Ohio and Susquehanna Rivers and the Appalachian Mountains. (While he did swim his herds across the Ohio River, it should be noted that it was before the river was widened and deepened through a series of dams built for navigation purposes.) With Harris, luck was seeing opportunity and putting his back to it, not winning the lottery.

Chapter 2
Early Days in Champaign County

A New County

Vermilion County, immediately to the east of Champaign County, was established in 1826. Its initial configuration was ten miles wider east-west and six miles shorter north-south than it is today. Seven years later, the population in the area immediately to the west demanded to be formed into a county of its own. State senator John Vance of Vermilion County—who also represented the unorganized area to the west—was asked to initiate legislation to establish the new county. Vance agreed to do so.

The legislation that Vance introduced created new boundaries for Vermilion County, reducing its width by ten miles and adding six miles to the north. It does not appear that any questions were raised at the time regarding the reduction in size of Vermilion for the creation of the new county. It was not until over a half-century later that Vermilion County historian Hiram Beckwith raised the issue by commenting:

> *Our member in the Legislature [Vance] acted unwisely, perhaps, in submitting to the loss of territory on the west side of the county in the organization of Champaign. The latter has the greater width of the two. The dismembered strip would have always been valuable to Vermilion, while the people living in it could have been, in all probability, as well, if not better accommodated had the old relations been maintained.*

I find it difficult not to take issue with Beckwith here. First, in the development of counties, starting in the southern part of the state, it was quite customary to reduce the size of earlier counties when creating later ones to the north. This made sense as populations increased and communications improved rapidly during the nineteenth century in Illinois.

Further, when looking at the size of the county, Vermilion is about average when compared with other counties in Illinois. There is also the factor of Danville, the county seat of Vermilion, located at its extreme eastern edge, virtually on the Illinois–Indiana state line. How could the lost western strip have been well served by a county seat so far away? Finally, Beckwith failed to take into consideration what Vermilion gained versus what it lost, given the values at the time. The six miles to the north were largely in timber while the ten mile strip to the west was prairie. At the time, the early settlers preferred the timberlands. Most likely, Vance thought that he was doing his home county a favor.

LOCATING THE COUNTY SEAT

Vance's legislation, in addition to delineating the boundaries, specified that the names of the new county and its county seat were to be Champaign and Urbana, respectively. The origins of the names become apparent when it is noted that Vance hailed from Champaign County, Ohio, and its county seat of Urbana. By Illinois statute, however, the location of the county seat was to be determined by three commissioners appointed from outside of the new county, under the assumption that they would be disinterested and make the best choice for the accommodation of the residents.

The small population of the new county was concentrated in three areas of timber along the Salt Fork and Sangamon River corridors and in Big Grove. Since Big Grove was centrally located and boasted the largest population, it was naturally the most logical place. The real question was where in the large grove the ceremonial stake would be driven. Of the three commissioners who were appointed, two showed up. After looking over several possible sites, the commissioners seemed inclined to choose a site in the northeast area of the grove. After all, this was where the Fort Clark Road ran, and the Van Buren post office was there. The area also contained the best timber and was where the most people lived.

According to J.O. Cunningham, it was getting late in the day, and Ike Busey, who lived in the southwest part of the grove—which had none of the

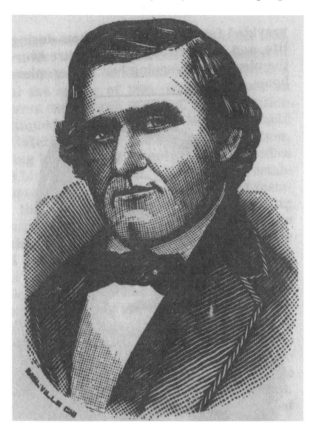

Matthew Wales Busey in an engraving from *Pioneers of Champaign County.*

advantages mentioned above—exclaimed, "Dod [*sic*], boys, don't drive so late in the evening; come go home with me and stay all night," an invitation which the commissioners accepted. That decision was fatal to the hopes of the northeasterners. The following morning the commissioners got as far as two hundred yards to the east of their overnight accommodations and drove the stake in where the courthouse stands today. The losers were unhappy, to say the least.

As noted by Cunningham:

> *It was long afterwards darkly insinuated to the writer, by men on the north side who had taken part, that influences akin to those in use in these later years, where official favors are sought, now known as "grafting," were made in the Busey cabin that night to aid in the final determination of the Commissioners.*

No other specifics are related in the early histories, but a story handed down in the Busey family was related to me by Garreta Busey in her later years. She had been told that Ike served up a fine supply of his homemade corn whiskey. I can just imagine the bleary-eyed commissioners as they staggered out the door of Ike's cabin, hardly able to make it as far as they did before they planted the stake.

Ike Busey was apparently the first of the Busey clan to arrive in the area. He purchased a cabin from William Tompkins, who had built it in 1828. That structure stood to the rear of where the Courier Building stands today near the Boneyard Creek. Busey was living there in 1833 in time to host the commissioners charged with locating the county seat. A second cabin was built nearby by Matthew Wales Busey. It fronted West Main Street where the Knights of Pythias Building stands today. The accounts are not clear, but it appears that it was the second cabin, that of M.W. Busey, that was subsequently moved to Crystal Lake Park, initially with the idea of housing relics from the early days of the county. Instead, at some point, it was converted to a concession stand and used for that purpose until it burned. Unfortunately, it was long gone by the early 1940s when I first became acquainted with the park.

EARLY ROADS

The first roads in the area began as traces, routes that the early pioneers followed. The earliest was the Fort Clark Road, which entered the state forty-nine miles north of the point where the Wabash River becomes the state line between Illinois and Indiana and terminated at Fort Clark, where present-day Peoria is located. It entered what became Champaign County along the north side of the Salt Fork River. It is speculated that it was a migration path of bison as they traveled to salt springs to the east, near the confluence of the Middle Fork River with the Salt Fork. Before the arrival of European Americans, there were bison in Illinois. This route was followed by the first pioneers and likely by the Native Americans before them. In 1826, as law often follows custom, the road was surveyed. In the early years, it was the way west across the area.

In no way did the Fort Clark Road resemble anything that we would call a road today. At most, it was a beaten-down path across the prairie or a barely cleared way through the timber. In wet areas, the road became quite wide as travelers instinctively attempted to avoid the mud. There were literally

no improvements—no pavements, bridges, nothing. In the early days of the county, other roads were also authorized and surveyed. They were blazed through the timber and marked by a furrow plowed across the prairies. Since most of the land was the property of the United States government, travelers were free to make their own way across the trackless wastes as best as they could when there was no authorized road.

As time passed and the county became settled, purchasers resented the "from here to there" roads crossing their lands at odd angles. This prompted the trend to push roads to conform to the east-west, north-south section lines, forming the square-mile grid patterns that we know today. At the time, however, with no provisions for maintenance, there followed an era of "bad" roads, for once the roads were confined to the narrow paths along section lines, travelers could no longer swing wide to avoid wet or otherwise difficult places.

EARLY TOWNS

Urbana, the new county seat, was the first real town in Champaign County. Next came Homer, which coalesced around the Moses Thomas water-powered mill on the Salt Fork River. Michael D. Coffeen, a land agent for an Indiana investor, decided that the location would work well for a town and accordingly platted one. It was a good choice because a mill site attracted traffic. Pioneers often came from considerable distances to have their grain ground. While they waited, they had time to shop or conduct other business. It was in the winter of 1855–56, when an east-west railroad—the Great Western/Wabash/Norfolk and Southern—came through one and a half miles to the south, that the ever-enterprising Coffeen orchestrated the move of all the buildings worth saving across the frozen prairie to the tracks. The lone holdout subsequently got his comeuppance. He found himself mighty lonely out there, and when he felt obliged to move as well, the opportunity to get in on the bargain rate was over.

Mahomet was the next town, coming about as the result of a change in the road west. When Urbana was created, the Fort Clark Road had to be moved to the southwest several miles. That changed the location of the Sangamon River crossing, where the town then grew up. It was first known as Middletown for its location, being approximately halfway between Danville and Bloomington. Middletown naturally wanted a post office. Upon application, it was discovered that there was already another town of that name in Logan County. The post office department could not have two

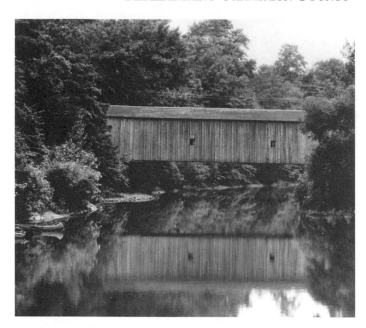

Homer covered bridge. *Courtesy Champaign County Archives of the Urbana Free Library.*

towns of the same name in the same state, so it designated their new facility Mahomet, presumably after the prophet of Islam; I think that some clerk in Washington had a sense of humor. The place existed with two names until the railroad came through in 1870, choosing the name Mahomet for its station to conform to that of the post office.

Sydney began as a land speculation. Two would-be entrepreneurs—Dr. James Lyon and Joseph Davis—upon learning in 1837 that a railroad was planned to come through the area, borrowed money and platted a town along the proposed route. Alas, the railroad scheme, financed by the State of Illinois, also with borrowed money, collapsed, leaving both the state and the entrepreneurs bankrupt when sales of their town lots stalled. Two decades later, when the railroad did come through, new investors took up the paper village and ran with it as a station on the line. To add insult to injury, the original plat, named for Davis's daughter, Sydney, was recorded incorrectly as Sidney, which is what it has remained ever since.

Last but not least of the early settlements was St. Joseph. When Urbana was established and the Fort Clark Road was moved a mile and a half south from Prather's Ford to accommodate the new county seat, it still had to cross the Salt Fork River. At the new ford on the east side of the river, Cyrus Strong established an inn. He subsequently sold the establishment to Joseph Thornton Kelley, a gregarious Irishman. Since the inn was on the then

new state road (1836) between two county seats, Urbana and Danville, it was frequented by the judge and lawyers—including Abraham Lincoln—riding the Eighth Judicial Circuit. Others joined Kelley and settled in the immediate neighborhood. There they remained until the 1869 coming of the Indianapolis, Bloomington and Western Railroad (IB&W) more than a mile to the north. The railroad—known to many of its customers as the "I Better Walk"—influenced the small settlement which, like Homer before it, heeded the call and relocated north to the tracks.

LIVING FENCES

Growing up in east-central Illinois, I could hardly avoid seeing numerous, long, straight stretches of trees along the borders of well-kept farm fields. Obviously, trees do not naturally grow that way. My father, who was at the university in the College of Agriculture, explained that the trees were Osage orange or hedge trees. They were first introduced into the prairie area in the late 1840s as natural fencing and remained quite popular until the invention of an effective form of barbed wire (Joseph Glidden of DeKalb, Illinois, patented the modern version in 1874). Hedge trees are easily recognizable in the fall by their most unusual fruit, which are green, dense, grapefruit-sized balls.

Rural hedge row. *Courtesy the author.*

During the middle decades of the nineteenth century, miles of Osage orange trees were planted for fencing in Champaign County and elsewhere in the upper Midwest. Considerable stretches survived into the twentieth century. My first up-close acquaintance with a hedge tree was with the extraordinarily large, sprawling specimen still growing in Trevett Park at the southwest corner of University and Prospect Avenues in Champaign, long before that area became a park. The grandmother of a high school classmate lived in the gracious, colonial-revival home just to the west, and we liked to play touch football in the space not occupied by the low, ranging tree.

The original range of the Osage orange tree (*Maclura pomifera*), also known variously as bois d'arc, bodark and bodarc, was along the drainage of the Red River in Arkansas, Oklahoma and Texas. It was prized by Native Americans for bows, owing to its exceptional strength and resilience. Agriculturists and nurserymen had experimented for some time with testing various species of woody plants in an attempt to find a plant that would work as natural fencing. Among those tried were hawthorn, honey locust and Osage, as well as others. The idea was to find a species when planted close together in a row would form a tangled mesh with its thorny branches capable of containing livestock. As the saying went, the fencing needed to be "hog tight, horse high and bull strong." The major proponent of the Osage fencing was Jonathan Baldwin Turner, noted educator and nurseryman at Illinois College in Jacksonville. When it was recognized that Osage would thrive north of its natural range and was effective, it quickly spread north.

Osage hedge fences did have their downside. While the seeds or seedlings were relatively inexpensive, the hedges were labor intensive to establish and maintain. Initially the hedge plants had to be protected from being trampled by livestock. They also required regular and extensive trimming on an ongoing basis. It took four to six years for the hedge fence to hold its own against livestock.

In their neglected state, the trees in the hedge rows grew to be thirty to forty feet in height and spread laterally. To compound the problem, invasive species joined the tangle. Initially, some farmers dealt with the problem with special plows that cut the ever-expanding root systems of the hedge trees to keep them from spreading too far into the fields. This reduced, but did not eliminate, the problems of moisture and nutrient depletion in the field margins adjoining the trees. The problems of shading and loss of tillable space remained. In the latter years of the twentieth century, farmers began the wholesale elimination of the hedge rows. This required large machinery to deal with the sturdy root systems.

Though with the twentieth century, barbed wire had largely supplanted hedge trees for fencing, hedge still had a value. The dense wood, which sinks in water, is extremely resistant to rot and came to be preferred for use as fence posts. Still, by 1950, hedge fencing had not been planted for over three quarters of a century, hedge rows remained to be a very distinct, year-round feature of the rural Champaign County landscape.

The more recent loss of the hedge rows has certainly changed the aesthetic aspects of the rural landscape. The windbreaks they afforded were also eliminated, allowing more top soil being lost to the winds blowing across the wide, flat prairie lands during the dry fall and winter months. The hedge rows also provided great cover and habitat for wildlife. I guess progress can be measured in different ways.

THE FIRST HANGING

I have always felt uneasy about the death penalty: its unequal application, the possibility of error and its proven failure as a deterrent. Today, add to that the cost of executing a person with the multiple appeals now required, which often take years. Such was not the case in 1898 when Richard Collier was tried, convicted and hung for the murder of Charles Freebryant in rural Sidney Township. The total elapsed time from crime to punishment was just three and a half months!

It was not the first murder trial in Champaign; that occurred in 1845 when William Weaver was convicted of murder and sentenced to hang. In that case, the hangman was cheated by Weaver, who was able to escape to healthier climes up north in Wisconsin. What struck me about the Collier case was the morbid detail provided by the newspapers.

It was late Saturday afternoon on the third of September when William Frees and a friend traveling along a township road some three miles southeast of Sidney came upon a grisly murder scene. Their attention had been attracted by several abandoned chicken coups, one of which was covered with blood. Seeing evidence of something having been dragged back onto a corn field, they investigated. Some twenty rows in from the road, they came upon the fly-covered body of a man, his face buried in the dirt, the arm by which he had been dragged still sticking up in the air.

Frees was quick to spread the alarm and within hours the road was clogged with the curious. County coroner Henry L. Penny was the first official on the scene. He was soon followed by state's attorney Andrew J.

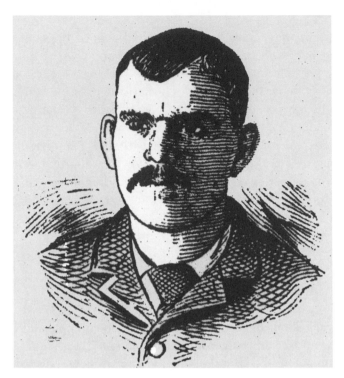

Richard Collier, in the *News* on December 16, 1898.

Miller, accompanied by a newspaperman whose rig nearly ran into the wagon carrying the deceased in the dust and congestion on the road. Penny quickly assembled a coroner's jury, which set up shop on the porch of Charles Bickel's house a quarter of a mile away, with all available lanterns being pressed into service to supplement the moonlight.

While the name of the deceased could not be determined, finding the cause of death was easy; he had been shot three or four times in the head and neck. He had been seen in the company of two accurately described, "extremely dirty" companions in an old wagon loaded with chicken coups drawn by a poor-looking team. The trio appeared to be in the chicken business. Champaign County was quick to offer a fifty-dollar reward for the capture of the dead man's companions and circulated their descriptions far and wide.

Just two days later, the suspects were recognized driving the wagon in front of the Champaign County Court House. For some inexplicable reason, after first traveling to Danville, they came to Urbana. These were hardly the best and brightest of murderers. Brothers Richard and John Collier, age thirty-four and twenty-five respectively, were quickly recognized and arrested. A

revolver was found in the wagon. The murdered man was soon identified as Charles Freebryant of Cayuga, Indiana.

On Wednesday, September 10, John Collier, described in one account as a "villainous looking fellow," confessed that it was Richard who was the murderer. Being unable to write, he subscribed to his confession with his mark. The following day, state's attorney Miller confronted Richard, who had been separated from his brother, with John's confession. Richard reportedly "laughed and joked about it" as his brother's confession was read. When Miller was done, Richard branded the confession as a "damned lie" and denied ever knowing Freebryant. Meanwhile, reports from Danville—where the Colliers resided—revealed that the brothers had had numerous encounters with the police, with John being regarded as the worst of the two.

When the trial began for Richard Collier on Monday, October 31, pretrial publicity initially made jury selection a bit difficult. One of Richard's court-appointed attorneys was Francis M. Green, father of legendary Urbana attorney H.I. Green. The evidence against the defendant was substantial. Witnesses were produced who testified seeing him in the company of the deceased. He had been arrested just two days after the murder driving Freebryant's team and wagon. A cellmate was produced, and he testified that Collier had admitted to him that he was the killer. Of course, brother John was called to reaffirm his earlier accusation.

The case went to the all-male jury (women were not allowed to serve) at 5:00 p.m. the following day. The jury deliberated all night and, finally, at 9:30 the following morning—over sixteen hours later—delivered a guilty verdict.

The *Gazette* reported:

> *When the verdict was read fixing* [Collier's] *punishment at death, he paid little attention to it; he gazed vacantly about him, and it would have been a nice point for a psychologist or metaphysician to determine whether he was absolutely indifferent or whether he was so dazed that he did not comprehend the situation.*

John Collier was tried next. Though Miller conceded that Richard had fired the shots, John was an accessory and equally guilty. His trial took eight hours and, at the end of it, he too was found guilty. He seemed relieved when told he would be sentenced to twenty-five years in the penitentiary. After hearing that his attorney filed for a new trial, the *Gazette* reported that John "became excited and said that he did not want another trial." He

apparently preferred twenty-five years in prison to a second trial that might have resulted in his hanging.

Attorney Green was not prepared to give up on his client. In an article in the *News*, on December 3, he was quoted as saying, "he was sure of one thing, that if the man (Collier) had had money and friends, that the outcome of the case would have been much different than it was." He further stated that it was "his belief that the people of Champaign County are not of such morbid disposition as to demand that the man's life should be snuffed out at the end of a rope." Greene believed that, due to the publicity given the case, it should not have been tried in Champaign County.

The *News*, based in Champaign, in a short article under the headline, "Draw the Line at Hangings," wanted to make it clear that the hanging was not going to occur in that city as many "provincial journals" seemed to suggest: "No such questionable glory [is] craved by our beautiful city." "A line," it continued, "is drawn at hangings." Green carried a last-minute appeal to the Illinois Supreme Court, which declined to intervene. The *News* reported petitions being circulated and, in final frustration, printed:

> *The better course would have been to take the matter before the Governor at once…insisting that this college community could not afford to have a hanging take place in their midst and would prefer that the prisoner's sentence be commuted to imprisonment for life. I* [presumably the editor] *am confident that the execution could have been avoided. Now it may be too late.*

As indeed it was, for the governor was out of the state.

The wheels of justice rolled inexorably on. Collier's execution was set for 8:00 a.m. December 16. The day before, Collier asked to inspect his coffin and the scaffold that was set up in a corridor at the northeast corner of the jail. The request was honored. He was up at 6:00 a.m. on the 16th for his last meal. Charles W. Feaster, the friendly scaffold builder from Springfield, was also up early and at the jail by 6:30 a.m., according to the *News*, "to see if everything was all right; over and over again the trap door was sprung and every knot and bolt was examined carefully and critically." The sheriff issued 250 tickets. Public officials were included as well as members of the press. A limited number were given to "those who wish[ed] to attend purely out of curiosity which strangely enough [was] a good many more than [could] be accommodated."

A crowd began to gather early in hopes of getting in. A few minutes before 8:00 a.m., the eight medical witnesses were admitted. Following the doctors,

the ticket holders were allowed in. Accounts differ, as to whether there were 100 or twice that number. Sheriff Lorenz appeared and requested everyone in the crowd to remove their hats.

At 8:08 a.m., the death party appeared led by Lorenz, followed by two deputies. Next came Collier's spiritual advisors, then Collier himself with his hands bound in front of him.

The *News* described the scene in detail:

> [He] *walked as firmly and looked as calm as if he was going to dinner.
> It had been the general belief that he would not weaken, but such coolness
> was hardly expected. Collier was dressed in a neat black suit with red and
> white carnations in the left button hole of his coat, and probably looked as
> well as he ever did in all his life.*

As Collier was positioned on the trap door, Lorenz said to him if he had anything to say, this was the time. Taking the opportunity, the condemned man spoke as follows:

> *I have but a few minutes to live and I ask God and you all to forgive me for
> my actions of the past five or six years. I hope God will bless you all and
> I hope to meet you all and my relatives and friends in heaven. Goodbye all.*

The deputies pinioned Collier's elbows behind him and strapped his legs just above the knees and at the ankles. The black hat was slipped over his head, and the noose was adjusted around his neck. With that done, a signal was given to the sheriff, who then touched the spring that launched Richard Collier into eternity. There was not the slightest movement in his body, even though his heart continued to beat for some time.

The body was then cut down and placed in the coffin that Collier had inspected beforehand. It was said to satisfy him; the county, it seems, wanted to do right by the man it was preparing to execute. A crowd followed the hearse west on Main to Broadway, then north to the Big Four Station, where the coffin was loaded on the eastbound train for Danville.

It is somewhat ironic that Richard Collier was not even buried in the grave that was dug for him. According to the *Urbana Courier*, in a story several weeks after the event, the grave had been prepared for Tom Pinnex, a black man and also a murderer who had been scheduled to hang the same day as Collier. Pinnex got lucky and was granted a temporary reprieve and later had his sentence commuted to life imprisonment.

POSTSCRIPT

Given the same circumstances today, Attorney Green was right; Collier would almost certainly not have been sentenced to death. Only two more executions were carried out in Champaign County. On October 21, 1921, Johnny Christmas died in what was a horribly botched execution when the noose failed, after the trap was sprung, to break the condemned man's neck. For twenty-two agonizing minutes, he hung there before he finally strangled. In 1927, the last execution occurred in the county. Subsequently, the state took over the responsibility for capital punishment from the locals. At least that represented some progress.

Chapter 3
Connections with Old Abe

KELLEY'S TAVERN

Kelley's Tavern stood for nearly three quarters of a century just northeast of the Old State Road crossing of the Salt Fork River. And, as already noted, its location lay along the route followed by Lincoln in his circuit-riding days. It is also fairly well established that on occasion the stop was frequented by the president-to-be, thus ensuring its place in the historical traditions of the county.

The original portions of the structure were built by Cyrus Strong, reported by Cunningham, around 1830–31. In all probability, the actual year was 1833 or shortly thereafter. That was the date of the creation of Champaign County and its county seat, Urbana, prompting the relocation of the original way west. While the new road was not officially surveyed until 1836, it became the de facto road almost immediately. Strong, who had entered land in the area, saw an opportunity to establish a tavern at the new ford. He was not only a budding entrepreneur, but also a preacher in the Disciples of Christ sect; in 1836, he was elected a county commissioner.

Enter Joseph Thornton Kelley. Kelley was from a large family in Champaign County, Ohio. Orphaned at fifteen, he was taken in by the Vance family, which lived in the vicinity; the Vances were involved in the salt business. As things developed, Kelley married Sarah, the daughter of John Vance. In the early 1830s, John was detailed by the family to manage the saline springs in Vermilion County, Illinois. Kelley, with Sarah, followed his father-in-law west to work at the salt works. When the resource became

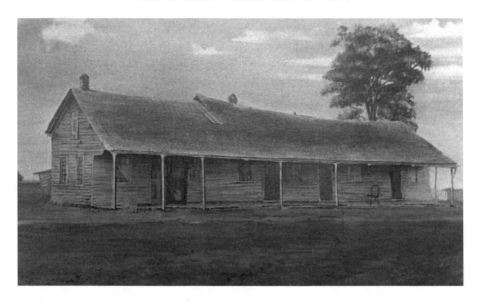

Kelley's Tavern, circa 1905. *Courtesy the author.*

unprofitable, Vance moved into politics. Beginning in 1849, the Kelleys first rented and then acquired the inn from Strong, who thereafter disappeared from the historical record. The tavern and ford became known as Kelley's tavern and Kelley's ford.

According to the *St. Joseph Record* of April 14, 1906:

> *The Kelley House was the scene of many gatherings of the sages and wise-acres of the village, who rendezvoused here to talk over war, politics, and to listen to arguments divers and numerous. In the cheery warmth of the old fireplace, jokes were rife and in this line it is said the innkeeper excelled.*

The location became known as St. Joseph when a post office was authorized there under that name, with Kelley being named the postmaster. A patron of the inn was credited as being responsible for the award. The story, as related in the 1878 *History of Champaign County*, is as follows:

> *It appears that at one time, a stranger came along and stopped with Joseph Kelley, the landlord, and the two became quite agreeable friends, and for several days had a jovial time together. When the stranger departed, Kelley, out of consideration of the good time they had had in company, refused to charge him, whereupon, the stranger told the landlord that he would*

Connections with Old Abe

'do something for him' for his kindness. Soon afterward, the stranger, who it seems, was some politician of more than ordinary influence, and in some way connected with the administration at Washington, secured the establishment of a post office, the need of which, during his stay at Kelley's, he had perhaps learned. Kelley was appointed postmaster, and in his honor, was called 'St. Joseph' from Kelley's first name.

It just so happened that shortly after the visit, Lincoln served a term in Congress and was on the House committee dealing with the Post Office Department. It also helped that Lincoln was a Whig with a Whig administration in office.

Kelley operated the inn until 1864, when he retired. He first rented and then sold his establishment to one Sanford Richards. Alas, the settlement was not destined to survive—at least not at that location. In 1869, when the railroad came through, everything except Kelley's Tavern moved north to the tracks. In 1883, the area of the original settlement, known as Old St. Joe, became the property of J.B. Swearingen, a descendant of early settlers. By 1893, the land had passed on to U.G. Swearingen, who rented the tavern to Lewis Jones and his wife, who resided there in the last years of the nineteenth century. The *St. Joseph Record* of August 24, 1901, described the building as being in a "fair state of preservation." After her husband died, Widow Jones continued to occupy the inn past the turn of the century until she too died. The unoccupied and neglected building began to deteriorate rapidly. The March 17, 1906 edition of the *Record* reported that the venerable structure was "getting very old and rickety" and would be torn down and removed, noting that it "will be greatly missed."

A subsequent story relating to the tavern appeared in the *Record* on March 7, 1918. It was prompted by an earlier story from an unnamed Indianapolis newspaper. The essence of the earlier story related to the memories of Mrs. Margaret Kelley Shreve. As Kelley's daughter, she grew up at the tavern and recalled the future sixteenth president of the United States being a guest. According to Shreve, Lincoln used a large rocking chair present at the inn. Well after the turn of the century, the chair remained as a cherished possession of the Kelley family.

The story also contained further information regarding the fate of the Kelley's Tavern building: While the tavern was taken down over a decade earlier, "the logs were all numbered and preserved;" owner U.G. Swearingen, a St. Joseph banker, planned to restore the building "to its original state for his own use as a summer home."

But following its demolition, no building stood on the Kelley's Tavern site until the twenty-first century when a private home was constructed there. For years, tradition connected a house north of the original location, partially built of logs, with Kelley's Tavern. It stands on the east bank of the Salt Fork upstream between the original site and the present village of St. Joseph. As it happens, the house was built on land owned by the same U.G. Swearingen.

Thus what had been a tradition and rumor is almost certainly based upon fact. While subsequent additions have obscured the log structure from the outside, hand-hewn logs form walls that run through the interior. It appears that remnants of Kelley's Tavern have indeed survived. It is quite likely the only surviving structure in Champaign County in which Lincoln stayed, albeit reconstructed at a somewhat-removed location.

A Murder Trial

The first murder in Champaign County for which there was a trial and conviction occurred in the fall of 1844. From the scant information that has

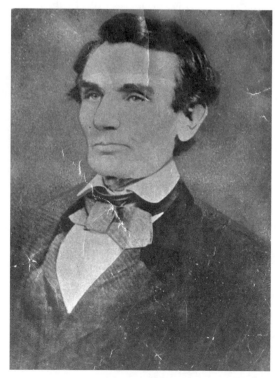

An Alschuler photo of Abraham Lincoln. *Courtesy Champaign County Archives of the Urbana Free Library.*

survived, it would appear that one William Weaver, described as "notorious and besotted," shot and mortally wounded David Hiltibran. Lincoln, fairly new on the circuit at the time, was appointed to defend the alleged murderer. In spite of what help Lincoln could offer, the evidence against Weaver was described as overwhelming. Weaver was convicted and sentenced to hang. While awaiting his day of judgment in the primitive county jail, Weaver, receiving some assistance from the outside, managed to escape. He headed north, where years later it was learned that Weaver had reformed and was a "useful, law-abiding" citizen.

THE 1858 SENATE RACE

Unfortunately, Champaign County was not one of the locations of the seven debates with Stephen Douglas during the 1858 campaign for the United States Senate. While losing the race, the debates were to make Abraham Lincoln a national figure. But both he and the Little Giant appeared in the county during that campaign. Douglas was first, on September 23, the last day of the county fair, before a large crowd. Abe arrived by rail the following day where he was met at the Doane House in West Urbana, a combination train station and hotel, by a crowd of enthusiastic supporters. Because the county fair was over, there was some concern that there would not be a crowd.

But Abe had a following in Champaign County, where he had practiced law on the circuit for many years. He was greeted by a crowd whose "enthusiasm was ten times as great" as that for Douglas. The scene was described by Cunningham as follows:

> *At an early hour the people began to flock into town, and by the time designated for forming the procession, the streets were so blocked up that it was almost impossible for a vehicle of any kind to pass. At ten o'clock, a procession led by the Urbana Brass Band, German band and Danville band, and over 60 young ladies on horseback with their attendants, 32 of whom represented the states of the Union, marched to the Doane House for the purpose of escorting Mr. Lincoln to the Fair Grounds, where the speaking was to take place.*

To best gauge the relative popularity of Honest Abe and the Little Giant in Champaign County, the presidential vote in 1860 was Lincoln, 1,720; Douglas, 1,251; Bell, 99; and Breckinridge, 12.

GRAND

Inauguration Ball,

IN HONOR OF

HONEST OLD ABE,

To be Given March 4th, 1861,

AT THE

DOANE HOUSE,

CHAMPAIGN CITY - - - ILLINOIS.

Yourself and Lady are Respectfully Solicited to Attend.

COMMITTEE

N. BEASLEY, Champaign		A. BERRY, Champaign
Wm. OLIVER, do		J. DUNLAP, Urbana,
GEO. SCROGGS, do		E. SHERMAN, do

MUSIC BY CLARK'S QUADDRILLE BAND.

None but those invited will be admitted.

BILL, $1.25

A Doane House invitation. *Courtesy Champaign County Archives of the Urbana Free Library.*

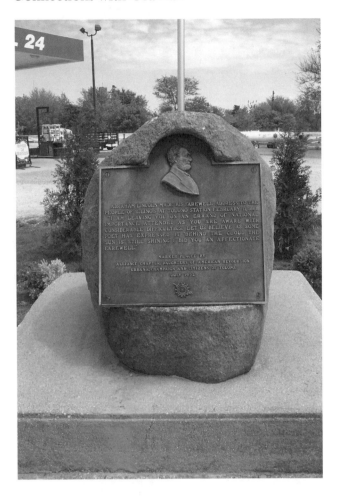

The Tolono Lincoln
Monument. *Courtesy the
author.*

THE LAST OF ABE IN CHAMPAIGN COUNTY

On the way to his inauguration in 1861, Lincoln's train paused briefly in
Tolono in the late afternoon. The president-elect appeared at the rear of
the train and made his last speech, albeit short, in Illinois. "I am leaving
you on an errand of national importance, attended as you are aware, with
considerable difficulties. Let us believe as some poet has expressed it, 'behind
the cloud the sun still shines.' I bid you an affectionate farewell."

A boulder in the vicinity of the former station commemorates the event.

Chapter 4
Railroad Stories

The Illinois Central

Growing up in the late 1930s and early 1940s, the available modes of long-distance travel were via the bus or the rails. For my family, it was the rails. We made the trip to upstate New York at least once a year, and a fascination with trains has remained with me ever since. Those hissing monsters of the steam era were especially intriguing. It was not until my mature years, when I began to delve into local history, that I realized how crucial to the development of Champaign County the rails really were. It is quite a story.

While canals had jump-started development in the eastern states—especially in New York with its Erie Canal—by the latter years of the 1830s, the rage was railroads. In 1837, the Illinois General Assembly was determined upon a great leap forward. In that year, it authorized an incredibly ambitious scheme of railroads and canals, but with money it did not have. Like most such legislative projects, there was a little something for almost everyone. One of the main components of the scheme was a central railroad that would run south down the center of the state from LaSalle–Peru to Cairo, at the confluence of the Ohio and Mississippi Rivers.

In less than a year, the great leap forward collapsed into a mountain of public debt with virtually nothing to show for the effort. Unlike New York's Dewitt Clinton, the driving force for the Erie Canal, there was no leader to force a concentration of resources on a single project. But the idea of a central railroad did not die. In 1850, Illinois senator Stephen A. Douglas engineered the Illinois Central land grant through Congress. Under the provisions of

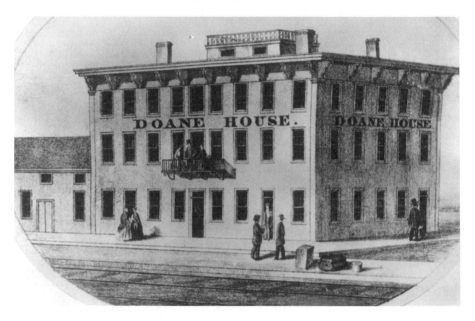

Doane House. *Courtesy Champaign County Archives of the Urbana Free Library.*

the grant, 2.5 million acres of government land were transferred to the state to finance a railroad. The lands involved were alternating sections like a checkerboard, with six miles on each side of the tracks for the three proposed lines. To make the proposal revenue neutral, those intervening sections retained by the federal government had to be sold before those contained in the grant at twice the former government price of $1.25 per acre.

The legislators, more than a bit singed over the 1837 debacle, chose a private corporation, the Illinois Central, headed by a Massachusetts legislator by the name of Robert Rantoul. In early 1851, survey crews were sent out to determine the precise routes of the three lines involved in the charter. The surveys were completed and the dirt began to fly before the end of the year. Fortunately for Champaign County, the line known as the Chicago Branch struck diagonally across the county from northeast to southwest. In the process, however, it missed the county seat of Urbana by nearly two miles.

A legend that refuses to die contends that the good citizens of Urbana were too foolish to recognize the importance of the railroad and failed to offer incentives for the tracks to run farther to the east. This is, of course, completely false. The IC charter only called for the company to build a branch line south from the rising metropolis of Chicago to connect with the main line at Centralia. The area across which that line would run was

largely a trackless wilderness. The route taken was driven by economic and engineering considerations rather than the need to hit every little hamlet that might be nearby. As it was, the tracks followed the spine of the county, with the Sangamon and Kaskaskia Rivers to the west and the Salt Fork and the Embarras to the east, sticking to the higher ground and avoiding significant bridging. Urbana, a frontier backwater with an 1850 census of 256, could hardly have had the resources and sophistication to divert so colossal an enterprise as the Illinois Central Railroad against such overriding construction advantages.

At a point close to where the State Road from Urbana to Bloomington crossed the railroad right of way, the railroad established Urbana Station. One might have expected the citizens of Urbana to do what Homer did at about the same time, that is, move west to the tracks. But the folks of Urbana were made of sterner stuff and stood pat.

THE HUMAN COST

On a rise just south of Champaign and east of the tracks is St. Mary's Cemetery. This site was the location of a construction camp while the Illinois Central was being built. Given the primitive state of knowledge regarding proper sanitation, the builders of the railroad at least knew that high ground for such camps was healthier than low ground. Disease, especially typhoid and cholera, were especially prevalent among the construction workers, most of whom were Irish. Either through accidents or disease, many workers died and were buried without much ceremony along the tracks.

In researching the building of the Chicago branch of the Illinois Central, details of the progress of construction were well reported, but related deaths due to disease and accidents are ominously absent. Railroad building indeed was dangerous work, and a worker's life just did not count for much in those days. I have heard that it was no accident that the Catholic cemetery south of Champaign developed on the St. Mary's site was started as a result of those early burials of Irish railroad workers. This has been difficult to confirm. But its location on higher ground and at the site of a construction camp certainly has made the story credible. A check of the earliest graves does not reveal dates sufficiently early to date back to the construction of the railroad, but such graves would, in all likelihood, have been rude and poorly marked. Thus, it remains a possible explanation for why the Catholic cemetery is there.

It was not just workers who were at risk. There were newspaper reports of a family of Prussian immigrants en route to Danville traveling south from Chicago in July 1854 to the then end of the tracks at Pera (later renamed Ludlow). A hack that ran back and forth to Danville had no room, so the father sent money for a wagon to come for the family. Without shelter, the family endured the intolerable heat for five days. During that time several family members came down with cholera.

Two more days passed with no help, and the desperate father with two of his young sons headed off toward Pilot Grove in Vermilion County, intending to reach Danville, some thirty-five miles away. They never made it. Before reaching the grove, one son died. The father left the other son with the body as he sought help. He failed to make it. It was left to the remaining, abandoned son to find assistance. When help finally arrived to what remained of the stranded family, the mother-in-law and the young daughter died as well. The mother and one son were all that was left of a family that left their native land for the hope and promise of America.

URBANA AND THE DEPOT

On July 24, 1854, the first regular train pulled into Urbana Station. The economic advantage of the railroad was immediately evident. The settlement around the Depot, as the location was soon called, was an area of considerable activity. Some folks and businesses did move west from the county seat to the new tracts opened for development.

New enterprises sprang up. The Depot and its immediate environs experienced rapid growth while Urbana stagnated. Less than a year after the arrival of the railroad, an effort was made to jointly incorporate Urbana and the Depot area. In a remarkable lack of imagination, interests at the latter objected in the mistaken belief that the "old" town would receive all of the advantages. Urbana then incorporated separately.

In 1857, the Depot incorporated as the village of West Urbana, taking the name of the post office that had been established there. Developers in the area of the railroad had big ideas. The first large plat completed by two engineers from the Illinois Central and a local landowner, Clark, Farnum and White respectively, contained a two-block space designated as a public square. Today, that space is the east half of West Side Park. It did not take much imagination to deduce what the developers had in mind. In the courthouse fight that followed, the established interests around the county

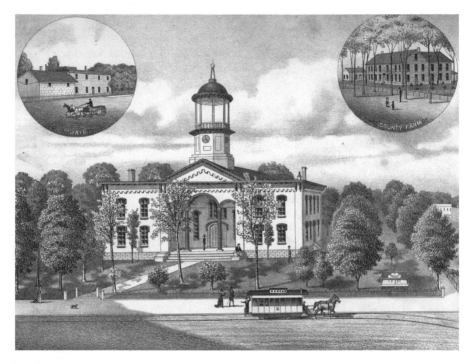

An image of the courthouse and Urbana railroad from *History of Champaign County, 1878.*

prevailed over the new upstarts and remodeled the building in Urbana to the point that it was virtually an entirely new structure, too costly to abandon. In 1860, West Urbana held an election to become the City of Champaign; this was voided by the state because no charter had been issued. Although the city seal says 1860, it took a second vote in 1861 to satisfy Springfield. There is more on the twin city relationship in stories to come.

THE GREAT COLONIZER

The Illinois Central was the great colonizer of east-central Illinois. The initial objective was to link two distant locations, Chicago and the junction with the main line at Centralia. But stations were established every four to seven miles, like beads on a necklace, to open up the largely vacant areas in between. The idea was to provide shipping points at reasonable distances for farmers lured by cheap land prices to ship out their produce. Thus, in Champaign County, the railroad established the stations of Pera/Ludlow,

Rantoul, Thomasboro, Urbana Station (which later became West Urbana and finally Champaign), Tolono and Pesotum. The stations further served the real estate interests of the railroad—sales of the land grant tracts to recoup the cost of building the railroad in the first place.

Following almost immediately was the Great Western Railroad, subsequently known as the Toledo, Wabash and Western, or Wabash for short. It established stations along its right of way as well, being responsible for Norrie (later named Ivesdale), Sadorus, passing through Tolono to Hall (later renamed Philo), Sidney and Homer. All of these stations soon became towns. The motivation was the same as that of the Illinois Central. While it did not have real estate to sell, it did bank on the sale of cheap federal land to bring in settlers.

The later steam lines, including the Indianapolis, Bloomington and Western and the Havana, Rantoul and Eastern also created settled places. The former was responsible for Ogden, a relocated St. Joseph, Bondville and Seymour; the latter for Penfield, Gifford, Dewey and Fisher. While these latter two railroads were ultimately abandoned, they as well as the older lines made their imprints upon the landscape, for wagon roads were built paralleling the railroads connecting those strings of towns, to be followed in turn by paved highways and interstates. Thus, the ultimate effect of the railroads was to determine the human geography of Champaign County.

DILLSBURG ON THE LITTLE RAILROAD THAT BARELY COULD

While the first four steam lines through Champaign County established strings of stations along their respective tracks—with most surviving to become incorporated municipalities—the two earliest lines were the most successful. The later lines generally did not fare so well, coming as they did into a marketplace of established competition. The Havana, Rantoul & Eastern (HR&E), the brainchild of Benjamin Gifford of Rantoul, is a good example. The stress on many of these smaller places became increasingly evident as options for surface transportation improved, making older and larger towns more accessible.

Of the stations on the HR&E, only Fisher and Gifford actually incorporated. Dewey and Penfield became recognized settlements. Dillsburg and Lotus were platted and had post offices but failed to get much further, existing today in name only. In the early 1980s, combining my love of biking

with an urge to see lost places, I made it a point to visit Lotus and Dillsburg. Lotus by the early '80s consisted of only a house or two. This was in spite of the fact that it had at one time been at the intersection of two railroads, the Chicago & Paducah (1874) and the HR&E (1876). By the time of my visit, the latter line was history.

Dillsburg was originally platted as Harwood, named for the township. The *Champaign County Gazette* of January 26, 1876 (taken from an article in the *Rantoul Journal*), carried a glowing report of the newly established station:

> *A desirable location on the line of the HR&E railroad, three miles from this place* [Rantoul] *has been selected by Dill and Thompson as a place for the first station east of here. These two gentlemen are making all efforts possible to encourage immigration. Corn cribs, coal bins and scales have been erected and a petition has been sent to Washington numerously signed, asking for a post office at that place, to be called Harwood.*

The petition was effective and a post office was duly approved in May 1876. By 1881, the name was changed to Dillsburgh (for guess who?). The post office survived until 1931. Sometime later, the pretense of the final *h* was dropped.

Dillsburg, in its heyday, was a bit more than just a station; in addition to two elevators, it had a blacksmith shop, grocery store, lumberyard and a dance hall. Large amounts of agricultural produce were shipped out of Dillsburg by rail, most importantly grain and livestock. To facilitate the latter, virtually all stations, including small ones, had stockyards that were generally owned by the railroads.

On my visit to Dillsburg, I had the good fortune to encounter Elmer Gehrt, who had lived within sight of the station for all of his seventy-seven years. One of Elmer's most vivid memories was of Sebastian Dill, the station's namesake and the railroad agent there for years and years. According to Elmer, "He [Dill] met every train, even on the hottest days of summer and the coldest days of winter, with a 'hard hat' [a bowler] and a vest."

Elmer recalled that in the old days, cattle for shipment were driven to the station by farmers on horseback. It was made easier as most fields were fenced, which helped to contain the cattle on the road. Today, the cattle drives are over and the fences are largely gone. "Most hogs," according to Elmer, "were hauled to the station in box wagons; it took a gentle team on the wagon as some horses did not like to hear the hogs squeal."

"In the winter," Elmer continued, "they even shipped wild rabbits out of here, by the barrel, fur and all." Apparently that was a common practice, for

another informant in Vermilion County related that he too hunted rabbits for shipment. His first batch was dressed and shipped north on the morning train. The evening train came with payment and a note requesting that in the future the feet be left on so that they could make sure the critters were indeed rabbits and not cats!

All that was left at the time of my visit were a grain elevator and an Illini FS operation. The railroad was scheduled for abandonment. It did not matter to the elevator folks, for the shipment of grain had long since been shifted to trucks. Today, the railroad—along with Elmer—is gone. The railroad was never profitable, and Elmer just wore out. It remains a place with a name and very little else.

A TRAIN WRECK

I first learned about this event from a novel, *The Windbreak*, written by my elderly friend, Garreta Busey. In her novel, she used stories related by her father and other members of this pioneer family. In his later years, her father, George W. Busey, had written a short memoir of his years prior to marriage. In it he related the following story, fictionalized by Garreta in the opening chapter of her book.

A young George W. Busey.
Courtesy Champaign County Archives of the Urbana Free Library.

Railroad Stories

In 1875, as construction of Gifford's line continued east beyond Dillsburg, a train bearing workers and materials would proceed out from Rantoul each morning to the work site; in the evening, it would return. When construction reached the vicinity of what became Penfield, it encountered a farm owned by Simeon H. Busey of Urbana, the father of George. The senior Busey, who was a large landowner and banker by profession, had five sons whom he wanted to learn the value of hard work. For George, then a sixteen-year-old, this involved being detailed for a year to work at that farm.

As noted in the *Champaign County Gazette*, on November 24, 1875, "Railroad companies are more troubled by suits on account of damages occasioned by injuring or killing livestock than from any other minor cause." And it just so happened that in spite of Busey's demands that cattle guards be put up by the railroad, some of his cattle had been killed. The senior Busey took direct action. Instead of litigation to resolve the problem, he directed son George to build a fence across the tracks to get the attention of the railroad builders. In her fictionalized account, Garreta had her grandfather saying: "That'll damn well make 'em stop and think—make 'em stop anyway." George, in his account, related that he went at the task seriously, apparently building something a bit more than a fence. But we'll let George tell the story:

Simeon Busey. *Courtesy Champaign County Archives of the Urbana Free Library.*

Father owned a thousand acres of land [with the later] *Village of Penfield at its center. We were to feed and winter through about two hundred head of cattle that winter. The new railroad had just been completed through our land…and the construction gang…* [was] *working on the east…The company had been warned a number of times to install cattle guards at several different points through our place but no attention was paid to his warning. So one time when father visited…he instructed me…to build a rail fence across the track on our east line. Boy-like of course, I built an extra good and substantial fence, much more solid than requirements called for.*

All this before the construction train was to return about dark.

It began to get dark that evening quite early, and as dusk fell I became a little uneasy. I wondered if I did the right thing in building that fence so substantial. I was alone and my thought would continually revert to that fence. Then I would speculate as to what the outcome would be if they did not see the fence in time.

Too afraid to watch, George heard the train's whistle, then the crash as a car or cars jumped the tracks and bounced along the ties, before tipping over. A few days later, the *Gazette* carried a story from the Rantoul paper:

On Friday night last, when the HR&E construction train was coming in with the workmen, it met an obstruction on the track near the county line, which proved to be a fence built across the track—probably for fun, which fact caused the caboose to be thrown some distance into the ditch. Twenty men were in it at the time, but only one was seriously hurt.

The HR&E, being a narrow gauge line, lacked the weight and stability of a standard gauge railroad. The rear car hit the barrier, instantly derailing. Cattle guards subsequently did go up but that was not the end of the story. According to George's account, several months later when Simeon Busey and B.J. Gifford were together the latter exclaimed: "If I knew who put that fence across the track, they would get what was coming to them!" Busey flared up and said: "If my son didn't do it, it wasn't because I told him not to." George continued: "They both pulled their coats off, but friends stepped in and stopped a good fight; nothing more ever came of it."

Chapter 5
The Industrial University

A Personal Reflection

My association with the University of Illinois actually predates my arrival on the planet. My father, John Paschal McCollum, came to Urbana in 1934 for his first professional position following his graduate coursework pursuant to a PhD from Cornell University. At about the same time, my mother arrived at Urbana as a transfer student from Cornell; her scholarship there could no longer support her enrollment due to the declining revenues of those depression years, and the University of Illinois was affordable.

While they had been at Cornell at the same time, they did not meet until they reached Illinois. They married a short time later. Children came, and it was not until 1943 that she finally earned her undergraduate degree. After making a name for herself in a legal action covered in a later story, she returned to complete her MA at the university. My older brother James was next, with a BS in geology in '56. I followed in '58 with a BS in political science. James returned for a JD degree; my son earned his BS in chemistry in '88; and I finally returned for a MA in geography. After forty years on the faculty, my father retired in 1971. My wife, Jeanette, joined the academic staff in 1976 and retired in 2000.

There never was any question where any of us were going to school—it was to the local land-grant school. No longer was higher education available only to the elite, primarily at exclusive eastern schools; the federal land grant college act indeed allowed for the democratization of higher education, and I, along with my family, received the full benefits.

HIGHER EDUCATION COMES TO THE PRAIRIE

Along with the Illinois Central Railroad, the other major development of significance to Champaign County was the establishment in Urbana of the Illinois Industrial University. At the time, the ultimate magnitude of its impact could hardly have been imagined. Without the presence and massive growth of this institution, Champaign County would be a very different place. The city of Champaign would have been just another small city along the Illinois Central, like Paxton, our neighbor to the north.

The idea of federal land grants to states for the development of educational institutions first surfaced in 1842. The leader in the effort was Jonathan Baldwin Turner of Illinois College in Jacksonville. Thirteen years later, the Illinois General Assembly petitioned Congress to enact the land-grant legislation to promote education. In 1857, legislation was introduced by Justin Smith Morrill of Vermont to do just that. When, in 1859, it finally achieved the approval of Congress, it ran into a veto by President Buchanan. The bill was again introduced in the next Congress following the departure of the southern states, but with the additional provision that military training be required in addition to agriculture and mechanics. Morrill's bill finally achieved passage and was signed into law by Abraham Lincoln.

Following the end of the Civil War, Illinois resolved to take advantage of the land-grant act. The question before the General Assembly then became where the institution should be located. Champaign County had just the place. In 1859, Jonathan Stoughton, a prominent clergyman from the northern part of the state, proposed a real-estate-development scheme to the locals in Urbana. Stoughton's proposal involved the purchase of a large tract of land in the western part of Urbana, which would then be subdivided into town lots with a large parcel set aside for the construction of a seminary once enough of the lots were sold.

A landowner in the proposed area, William H. Romine, and another local, J.S. Wright, were early backers. A person familiar with the western portion of Urbana might recognize those names as well as Stoughton's, all surviving on street signs. The real estate scheme was supported, and the project went forward, achieving a sufficient level of success to provide for the seminary building. When built, it stood approximately where Beckman Institute stands today. The five-story brick structure was the largest building in either Urbana or Champaign. Unfortunately, there were no specific plans for what entity was to make use of the building. Dr. C.A. Hunt, who had chaired one of the early meetings promoting the project, suggested offering

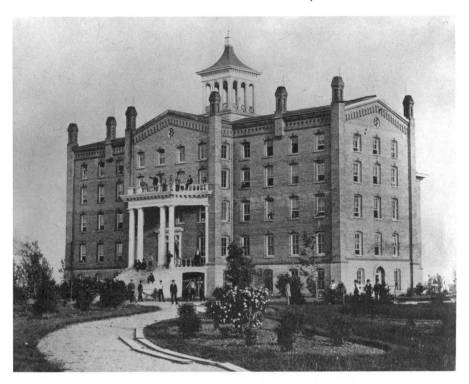

The Champaign Elephant. *Courtesy Champaign County Archives of the Urbana Free Library.*

the building to the state for the future college that would be established under the Morrill Act.

The timing was right. By 1865, the Champaign County offer had been approved by the House of the Illinois General Assembly. Delaying tactics held the matter up in the Senate, and the session ended before final action could be taken. In the meantime three other counties entered the sweepstakes—Lincoln, Logan and McLean. With serious competition involved, the state began to weigh the various offers. Champaign County voters approved funds to further support their bid.

Enter Clark Robinson Griggs. Originally from Massachusetts and having two terms in the state legislature there, Griggs arrived in Champaign County in 1859; he purchased land in the Philo area. After a farm accident that resulted in a severe injury to one of his hands, he moved into Urbana. The outbreak of the Civil War found him as a sutler, supplying food and drink to a fighting unit from the county. Following the war he served for a short while as mayor of Urbana. But Griggs's talents were needed for a much larger

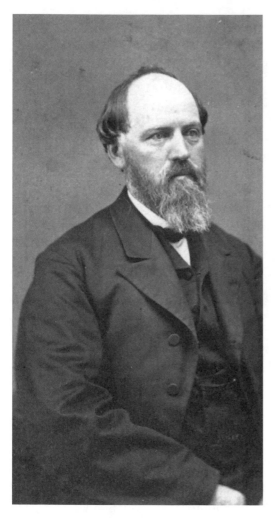

Clark Robinson Griggs. *Courtesy Champaign County Archives of the Urbana Free Library.*

task. With his legislative experience behind him, he was the consensus candidate for the state legislature, which was again poised to deal with the location of the land-grant university.

In the meantime, in spite of the earlier success, competition for the school had stiffened considerably. When the 1867 session opened, the Champaign booster committee took rooms at the Leland Hotel in Springfield and set up a first-class hospitality suite for state legislators. At the same time, Griggs went to work. As a freshman member of the Illinois House, Griggs was somehow able to make himself a credible candidate for speaker. His strategic withdrawal put him in a position to be named chair of the committee tasked with deciding where the land-grant school was to go. His easy manner also allowed him to win friends among many of his colleagues, most importantly those from counties not in contention for the prize.

The detractors were quick to point out that Champaign County was really a backwater location, and that the locals were trying to pawn off on the state a lemon of a building which the opponents termed the Champaign Elephant. In fact that was just what the folks in Champaign County were trying to do. Perhaps the strongest competition came from Jacksonville in Morgan County and from its strongest advocate, Jonathan Baldwin Turner.

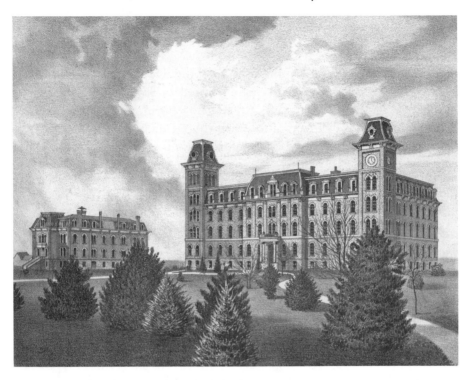

Early university buildings, with Harker Hall on left and University Hall on the right, as seen in *History of Champaign County, 1878.*

But Morgan County had already done well in garnering state institutions: the school for the deaf and dumb (opened in 1846) and the state school for the blind (1865). I am sure that Griggs was quite effective in pointing out to his colleagues that this was pork enough.

A factor not to be overlooked was the location of the Illinois Central Railroad. After all, the Chicago branch had been included in the Illinois Central Charter at the insistence of the growing metropolis to the north. The presence of the railroad provided easy access to a Champaign County location and not to the other three counties in contention.

Between the comforts of the hospitality suite and Griggs working among his fellow legislators, presumably offering encouragement and support for their pet projects, he soon felt sufficiently confident to bring the matter before his committee, where it was approved easily. When the matter was moved on to the House as a whole, it was again approved by a comfortable margin. A short time later, Griggs saw that the issue was moved on to the Senate with similar results.

Turner was outraged. Of the four county proposals offered to the state for the university, Champaign's was valued the least. He reportedly said that it was the first time he had seen the prize knocked down to the lowest bidder. Clearly, Griggs was a master of manipulation in orchestrating the result. But, in 1867, it was difficult to imagine just how big of a plum the university would become. Had members of the General Assembly been able to read the future, the competition would undoubtedly have been a whole lot stronger.

RUMORS

An oft-repeated rumor has it that Urbana got the university, and Jacksonville got the Illinois Asylum for the Education of the Deaf and Dumb. While it seems clear that Griggs did a bit of horse trading to get the university, the state chartered the asylum in 1839, some two-and-a-half decades prior to the selection of Champaign County for the university. Of course, Griggs might well have argued that Logan County already got its pork from the state. Another rumor was that Pontiac got the prison, while Champaign County got the university. Livingston County had not even entered the university sweepstakes, and the prison did not open until the early seventies, four years after the university decision. There was also a rumor that the university came to Urbana, and Danville got the veteran's hospital. But the former decision was made in 1867 by the state legislature, whereas the latter was made by the federal government in the 1890s, most likely the gift of Uncle Joe Cannon, member of Congress from Danville and later the speaker of the United States House of Representatives.

THE EARLY ACADEMIC BUILDINGS

In 1869, the Illinois Industrial University opened its doors with the Elephant being the main building, thus providing University Avenue its name. It was soon followed by the construction of University Hall on Green Street, some five blocks directly to the south. Champaign County's gift to the state was not destined to survive for long. After a few years, a wind storm blew off a corner of the Elephant. After standing derelict for a year, it was decided that the building was beyond repair, and it was torn down.

It is not by accident that the other early buildings were erected on the east side of Wright Street, in Urbana, since the land involved in the Stoughton

scheme was on the Urbana side. Early on, University Hall was joined on the east by Harker Hall, the only academic building to survive from those earliest days. In fact, most of the academic facilities on the campus continue to lie on the east side of Wright Street to this day. It was not until the early years of the twentieth century that university facilities began to expand west into Champaign. And even then, while occupying large areas, the facilities were—and remain so today—related to athletic facilities, student dorms and campus administration. The main exceptions are law, education, psychology, business, architecture and art.

While many of the land grant colleges included *A&M* in their names, the new institution in this state was known as the Illinois Industrial University. In 1885, the name of the institution was changed to the University of Illinois. According to former university archivist Maynard Brichford, the change was "to indicate the aspirations of faculty and alumni and avoid confusion with schools for delinquents."

Chapter 6
Some Memorable Citizens

A Funny Man

"Lem Putt—that wasn't his real name—really lived. He was just as sincere in his work as a great painter whose heart is in his canvas." That is how Charles "Chic" Sale introduced his classic piece of prairie humor known to the world as *The Specialist, or the Champion Privy Builder of Sangamon County.* Lem was already among a dying breed when, in 1929, he was immortalized by Sale. He was a victim of progress because, unfortunately for men like Lem Putt, progress included such novelties as indoor plumbing and flush toilets. You see, Lem specialized in the construction of privies or outhouses, or—as they came to be known by many following the publication of his little book—Chic Sales.

Charles "Chic" Sale is a largely forgotten person today even in the town where he grew up. Though born in South Dakota in 1884, Chic's formative years were spent in Urbana, Illinois. In his youth Chic was reported to be a truant officer's nightmare. He apparently benefited from time out of school for his knowledge of the small town and rural folks, which he often portrayed on the stage. He was both humorous and understanding. Before Chic left Urbana for good, his stories and antics played to capacity audiences among his co-workers at the Big Four Railroad Shops in Urbana. He began as a vaudeville performer but eventually wound up in Hollywood. His specialty, as one would expect, was as a character actor playing the part of a rustic or rube.

I became acquainted with Chic Sale through my father who, when he came to Urbana in the early '30s, lived in a boarding house just down the

street from the Sale family. He did not have the good fortune of meeting the talented actor—then long gone from Urbana but whose humor my father greatly admired. Because of his talents as a humorist, Chic was asked on occasion to be an after-dinner speaker. And in 1929, he came up with *The Specialist*, his most memorable routine, which was later published as a small book. In the speech, Sale assumes the persona of Lem Putt, the privy builder. Those of us who are older and have had the experience with outhouses find the story hilarious. Unfortunately, the younger, modern reader just does not get it.

Possibly the last movie in which Chic appeared was *The Perfect Tribute*, filmed just a year before his untimely death in 1935. It was an adaptation from a short story—a fictional account of Lincoln's initial perception that his address at Gettysburg had not been well received. In the course of the film, following the speech, Lincoln has a chance encounter with a dying, blinded Confederate soldier who tells the president how much he admired the speech after someone read it to him. (In fact, Lincoln was initially troubled that his iconic speech had not gone over well.) Until 2009, it was thought the film had been lost. A member of the board of the Champaign County Historical Museum located a copy that was subsequently shown at LincolnFest, a film festival in Champaign that was part of the Lincoln bicentennial observance in 2009. A DVD of the film was then donated to the Lincoln Presidential Library in Springfield.

Chic continued to make news locally long after he left Urbana. The following is from an article in the *Urbana Daily Courier*, dated November 10, 1932, regarding the removal of the Busey cabin to Crystal Lake Park. (See also the first story in Chapter 7.)

> *When this cabin was removed from its original site…a human skeleton was found beneath it, to the intense excitement of the populace, who imagined that a murder had been committed years back and the body concealed there. Years later it came out that the Huck Finn and Tom Sawyer element of the town had put the bones under the cabin to produce just what the discovery did produce—a thrill for the townsfolk. The now famous "Chic Sale" was in on the hoax. Incidentally, it may be said that the only person who did not appreciate the joke was the grandfather of one of the boys, a physician, who was minus a perfectly good skeleton as a consequence.*

It was a great loss to the world of humor when Lem—I mean Chic—died of pneumonia at the age of fifty-one in Los Angeles. His younger sister,

Virginia Sale, was also in show business, an accomplished actress in her own right. There is a postscript to the Sale story. When my mother arrived from Rochester, New York, on the Big Four Railroad in the early '30s to attend the university, she was shocked at seeing so many outdoor privies behind houses as the train entered eastern Urbana.

PAUL LAUTERBORN

Several decades back, when I used an electric razor, the screen head began giving way, as they invariably did. I resisted doing anything until a large chunk flew away and the cutter underneath came so close to performing a tracheotomy on my neck that I definitely needed a replacement. It was either that, resort to razor blades or grow a beard. The bad news was that the razor was twenty years old.

Paul Lauterborn in his store with grandson on the counter. *Courtesy Gay Mahnke.*

I headed off to downtown Champaign in search of the crucial part. In the course of my search, I paused for a moment of silent nostalgia in front of 117 North Walnut Street, the former location of the late Paul Lauterborn's appliance and supply shop where I knew I could have found just what I was looking for. All that was visible through the dingy windows was a sea of refuse awaiting the industrious cleaning efforts of a new tenant. Gone were the ceiling-high stacks of boxes containing everything from a float valve for Thomas Crapper's first flush toilet, a two-train transformer for the 1952 Lionel Express, parts for every known toaster, coffee percolators—you get the idea.

More amazing than Paul's complete collection of spare parts for nearly everything under the sun was his uncanny ability to disappear into his towering inventory with hardly space to turn around and return moments later with the exact item desired by the customer, regardless of how exotic the part sought. Paul was the patron saint of the repair-rather-than-replace crowd in Champaign–Urbana. Cutting a deal with this crusty character was an experience in itself. My thought was, "Where are you, Paul, when I need you?"

Seichi "Bud" Konzo

Both Champaign and Urbana have large urban forests. I used to marvel while standing at the top of the west balcony of Memorial Stadium at how little of the city of Champaign was visible for the trees. Our yard and adjacent parkway had five sizable American elm trees. Every fall the yard was awash with leaves that we had to rake to give the grass a chance in the spring. My father was allergic to the smoke of burning leaves, so we always loaded what we raked into bushel baskets and dumped them behind the evergreen trees up close to the house. As a youngster, it always amazed me how the mountains of leaves would disappear by spring.

Most of our neighbors burned their leaves in the street. For much of the fall a pall hung over the city. The problem was not just the air pollution; people burned leaves on asphalt streets, often did not mind their fires, allowed them to occasionally get out of control or raked what remained down the nearest sewer to clog up the storm drains. Cities, as a consequence, began enacting burning bans and buying various types of equipment to collect leaves from the gutter, but there remains no perfect answer.

Then there was Seichi "Bud" Konzo. He lived just four blocks from us; his oldest daughter, Margaret, was a classmate. Bud, a Japanese American,

arrived in Champaign–Urbana in 1927 from the West Coast to continue his studies in mechanical engineering. And like many former students, he never left; he became a long-term member of the College of Engineering faculty. As far as I could tell, the Konzos were a quiet, rather self-contained family.

By the time I got around to interviewing Bud in October 1982, he was seventy-seven years old. I was attracted to him for his unique approach to the problem of leaves. For the previous thirty-five years, he had unobtrusively gathered up the leaves and grass clippings of his own yard and the two adjacent yards, along with those in the street gutter, and then applied them to the benefit of his garden and flower bed. One would think that handling such a large volume of organic material would require a large area. Not so. The enclosed, rectangular area holding his compost was only five feet by fifteen feet, which he calculated as being less than 1 percent of his entire lot.

Each year, Bud piled new leaves and grass cuttings at the north end of the enclosure. In the spring, he repositioned the developing compost to the south end, which freed space for more leaves the following fall. Throughout the summer, he used the organic-rich material which he created on his garden and flower bed.

In the entryway to his side door, Bud had a chalkboard. At the time of my visit, he pointed to the number forty-one among other notations. "Being an engineer," Bud noted, "I love to quantify." He continued: "That represents the number of wheelbarrow loads of compost I have distributed so far this year." A glimpse at the compost enclosure revealed that perhaps just four loads or so were left. Quickly calculating in his head, Bud continued: "Each load weighs about 50 pounds, which means my output for this year comes to about 2,050 pounds."

Bud went on to point out the cumulative effects of his thirty-five years of effort on his garden. The ten-foot by thirty-foot garden plot was nearly six inches higher than the surrounding yard area, all composed of the unimaginably rich top soil he had created. Other than the two families supplying him with leaves and grass clippings, he doubted whether any of the other families in the neighborhood were aware of his operation, although they might have noticed him sweeping the street gutter.

I thought at the time that if everyone operated like Bud Konzo, the city would not need street sweepers; there would be fewer clogged storm drains and much less air pollution in the fall. Today, both Champaign and Urbana have banned leaf burning, but the leaves still must be picked up and disposed of, creating a public expense and a sizable market for large, heavy-duty paper bags. Any way you slice it, in his time, Seichi "Bud" Konzo stood out as an unusual citizen.

Chapter 7
We Call It Progress

BRIEF MEMORIES OF TWO PARKS

Crystal Lake and Hessel

Growing up in Champaign–Urbana, two parks in particular hold special memories for me. The Busey cabin, in Urbana's Crystal Lake Park, which was mentioned in an earlier story, would certainly have been an attraction for me had it survived. But alas, it did not. I remember well the old boathouse standing at the edge of the park's lagoon. Row boats could be rented there. As a four-year-old, walking between the tethered boats, the vessels parted and into the drink I went. I recall that I was not quiet announcing my predicament! The boathouse has been history for years. Of greater significance to me was the loss of the World War I artillery piece positioned atop Cannon Ball Hill, presumably providing the location its name. As a child our family regularly visited the park, and the first thing I headed for was the cannon. Sadly, in a moment of patriotic fervor, this venerable weapon of war was towed away in a World War II scrap drive—an example of beating swords into swords. The park was never again as much fun. I imagine had the cannon survived the war the park district's insurer might well have condemned it as dangerous and required its removal.

That was the fate of the old firetruck in Champaign's Hessel Park. My son loved that shell of a fire wagon, and, upon every visit, he headed for it at a dead run. It did survive long enough to be condemned by the insurance folks as dangerous. How did we ever survive infancy in those bygone days?

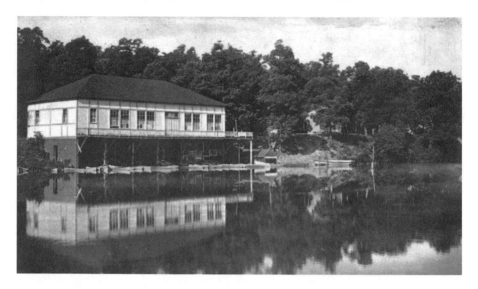

Boathouse at Crystal Lake. *Courtesy the author.*

Shelter at Hessel. *Courtesy Jeanette McCollum.*

What has survived in Fred Hessel's park is the wonderful shelter at the north entrance. Completed in 1934 by workers of the Civil Works Administration, a federal employment project, it was touted as a work of "permanent worth to the community." And overbuilt it is! While nothing in this world is permanent, that shelter comes close.

THE CHAMPAIGN DOWNTOWN FOUNTAIN

I had long known that the neglected monument standing in the middle of Champaign's Scott Park, just west of the campus area, had formerly been the downtown fountain once located near the northeast corner of Neil and Hickory Streets. My knowledge stemmed from several images of the intersection of Main and Neil Streets in my collection of vintage postcards. On October 6, 1904, the fountain had been installed and the water turned on by then mayor E.S. Swigart. It was removed to the park, quite possibly as early as 1918, during the flu epidemic. Being a traditionalist, it seemed to me that the fountain should be restored and returned to its original location.

Long after the removal of the fountain, in the 1950s, a monument to Abraham Lincoln was erected near the original location of the fountain. It was called the Lincoln Megalith—more on the Megalith later. Another strand of the story occurred when I became mayor of Champaign in May 1987. Shortly thereafter, former mayor Joan Severns (1979–83) came in to

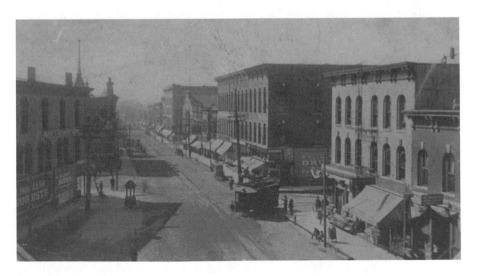

Main and Neil with the fountain in the lower left. *Courtesy the author.*

see me bearing a flat heavy package. Inside was a bronze plaque bearing the following description:

> *Susan B. Anthony*
> *1820–1906*
> *Women's rights–anti-slavery agitator*
> *Lectured on 'Work, Wages and the Ballot'*
> *April 2, 1870*
> *In Barrett Hall on this site*

Barrett Hall was an early building situated on the northeast corner of Main and Neil/Hickory Streets in downtown Champaign, adjacent to where the fountain had once stood. Severns and four other women—Laura Chance Keller, Diana S. Lenik, Mary Lee Sargent and Helen Foster Satterthwaite—had commissioned the plaque to be affixed to the wall of the building then standing on the site, the former Grant's Department Store. The Grants store was the third building to occupy that location. The owner at the time refused to accommodate the women, so the plaque was entrusted to Joan's care. Her mission that day was to assign to me the responsibility of getting the plaque placed somewhere near the site of the Barrett Hall.

At about the same time that I was given custody of the plaque, a fire burned out much of the block with the exception of the Grant's building which received only minor damage. It stood vacant under new ownership, derelict and ugly. While the new owner would probably have been more amenable than the former, the building in its derelict condition was no place for the commemorative plaque. When all redevelopment efforts for the block failed, the city purchased the site. When the buildings were leveled, including the Grant Building, the site became a city parking lot.

For seven years, the plaque rested against the wall of the mayor's office awaiting an opportunity for its placement. With the site now under city ownership, the time had come to do something about the Megalith, the old fountain and the plaque. Main and Neil had once been the main intersection of downtown. Both of the substantial buildings that had defined the intersection on the north side were now gone, and something needed to be done to the corner.

I approached Bill Helms, president of the park board, and parks director Robert Toalson about regaining possession of the old fountain and offering the Megalith for placement in one of the parks. They were willing to accommodate me on the former; I do not know how excited they were about

the latter, but they did agree to take it. John Hirschfeld, then in charge of the *News-Gazette*, agreed that the newspaper would provide the major support for the removal, restoration and placement of the fountain. The major downtown banks at the time—the Champaign National Bank, Bank Illinois, Bank One and First of America—agreed to provide the remainder.

April 29, 1994, saw the finishing touches on the reconstructed fountain. It was situated within a few feet of where it originally stood. Subsequently, it was surrounded by the Susan B. Anthony plaque mounted atop a short, shiny black stone pedestal, a similar black stone that named the financial sponsors of the fountain project. Another plaque previously in the area but is now relocated for more visibility honors Frank K. Robeson "for his continuing efforts toward community beautification." Later, a dedication ceremony was held to commemorate the restored fountain and the placement of the Anthony plaque. Former mayor Severens was present and an honored guest at the event.

COMMERCIAL AIR SERVICE COMES TO CHAMPAIGN COUNTY

From my earliest years I remember the small airport at the northeast corner of the road intersection known as Five Points located northwest of Champaign. The intersection was formed where the east–west and north–south section roads were intersected at an angle by the Bloomington Road. The most distinctive feature of the airport was a large metal hangar with sloped sides. I did not know until years later that it was the first serious effort to bring commercial air service to Champaign County.

It was, however, not the first effort. Some time earlier, Fred Hessel, described as a "wealthy and eccentric" businessman in Champaign, had a flying strip and hangar just northeast of Hessel Park between Hessel Boulevard and Birch Street. Hessel (1866–1939) is best known today for the boulevard and park bearing his name. They were intended to be a part of a residential development designed to tie into the southern portions of the University of Illinois campus.

Hessel's effort failed to go anywhere thus initiating the far more determined effort to connect Champaign with the airways northwest of the city. That was initiated during the latter half of 1928. The moving force for the project was a committee of the Champaign Chamber of Commerce, chaired by local financier Gordon Bilderback. Referred to variously as

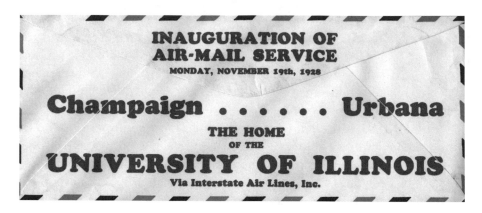

An air-mail envelope. *Courtesy the author.*

the Champaign Municipal Airport, Champaign Urbana Airport and the Chamber of Commerce Airport, it was situated on 116 acres leased from a Burnham heir, Mary Bruce Harris, at the southwest corner of Section 35 of Hensley Township.

Steel for the large hangar, measuring eighty feet by a hundred feet, was ordered from a firm in Pittsburgh. A local firm, King and Petry, was contracted to erect the structure.

Faced upon a framework of structural steel, the western walls were slanted to ensure protection against winds sweeping from that direction. The hangar's entrance faced east to protect it from those same winds.

The building was further described as being fireproof, not surprising for what appeared to be an all-metal building. It was said to be sufficiently capable of housing from six to ten airplanes. While the hangar was obviously a sizable structure, airplanes were much smaller in those days. By the beginning of the twenty-first century, the location had long ceased to serve the needs of civil aviation, but the hangar endured until 2009 when it was torn down—yet another distinctive landmark gone.

But back in 1928, the coming of an airport was a big deal. According to the glowing newspaper account, the airport was going to meet Class A standards, and wind cones were going to be installed. These were described as "long fabric tubes with openings at each end" which would tell flyers the wind direction. Also there would be light beacons to show the way for night flyers; in those early days, pilots navigated largely by sight. Permission was sought to mark area highways with the name of the city, with large arrows that could be seen at several thousand feed pointing the way to the

airport. A massive arrow was painted on the roof of Robeson's Department Store, 120 feet in length, 16 feet wide. Inside of the arrow, "Champaign" was spelled out. Below the big arrow was *2M*, which indicated the distance to the airport; a smaller arrow marked *N* represented true north.

The field itself was described as "not much more than raw, open land." Plans were underway to "melt down" some of the irregularities in the grass landing strip and develop a turf that would resist being torn up by air traffic and provide for a soft, cushiony landing. The report continued, "No doubt the airport will be equipped with a record book in which pilots and passengers will register their names." So much for the formalities of the time.

Air passenger service was to begin on the tenth of November. The aircraft employed was described as a Fairchild, capable of carrying six passengers in addition to mail and baggage. It had a forty-four-foot wing span and was powered by a Pratt-Whitney-Wasp engine of 410 horsepower. It had a cruising speed of 110 miles per hour and would fly between one and two thousand feet. Passengers were allowed to carry on their luggage for free, up to twenty-five pounds. That contrasts with today's regional jets, which carry as many as fifty passengers, operate up to thirty-five thousand feet and are capable of airspeeds exceeding 500 miles per hour.

Local boosters were solidly behind both the passenger and air-mail service slated to begin nine days later on November 19. In anticipation of the latter, twenty thousand specially prepared envelopes were printed announcing the grand event and were made available at the Champaign Chamber of Commerce, Urbana Association of Commerce, Illinois Union Building and all local banks, hotels and post offices. The inauguration of air-mail service was a major event. Champaign postmaster O.L. Davis reported on the seventeenth that some twelve thousand of the air-mail envelopes had already been turned in. Davis was confident that the huge amount of mail could be accommodated. What concerned him was the fact that continuation of air-mail service was totally dependent upon the level of local use—use it or lose it as they say.

Alas, airmail and commercial passenger service failed to last out the year; Champaign–Urbana was just not ready for prime time. Nevertheless, the airport was an ongoing concern. Just six months later, the airport had an advertisement placed in local papers announcing a fly-in of the "Monarch Food Ship, the Independence." Described as the Pioneer Food Display of the Air, the plane carried enough Monarch food products "to stock a small grocery store." The aircraft was a Ford tri-motor, a "huge ship...identical with the Ford plane now in use by Commander Byrd on his Antarctic expedition."

The airport survived into the 1950s, but commercial air service had since moved on to facilities developed by the University of Illinois well to the south of Champaign where there was room to accommodate modern aircraft. The 116 acres of that first civil aviation facility in the county, which accommodated Ford tri-motor aircraft, is dwarfed by the 1,799 acres at Willard Airport required both for airport facilities and buffer areas to accommodate the jets of today.

THE TWO SHOULD BE ONE

Merger Issues

One of the most contentious issues to surface in my lifetime has been the question of merging the cities of Champaign and Urbana. Being among the university-oriented families, my parents could see no reasonable benefit in the twin city arrangement, but there was a serious disconnect between town and gown folks regarding the merger when it was proposed in the early 1950s. To provide a little background, a bit of history might be useful.

With the failure of the effort at joint incorporation of Urbana and the Depot area in 1855, the matter rested until early 1911 with the visit of President William Howard Taft. Regarding the twin city situation, the president told university president Edmund James "the two should be one." James, an administrator who could take a suggestion, called a group of civic leaders from both cities to discuss the idea. The group was composed of five appointees each named by the mayors of Champaign and Urbana plus five from the university.

The meeting was held, and the minutes survived in the university archives. The people elected to leadership posts were Chairman George W. Busey, of Urbana; vice chair R.R. Mattis, of Champaign; and Secretary J.M. White, a professor at the university. After a general discussion, member H.I. Green moved, "The mayors of the two cities, with President James and the chairman and vice chairman of the meeting constitute a committee of five to consider the arguments that had been presented with power to reconvene this committee...for further consideration of this question."

University archivist Icho Iben, who produced the minutes, added an addendum: "From the language of the last paragraph and the lack of further documents, but most of all because we still have a border line and two sets of governments, I conclude that nothing further happened." Forty-two years

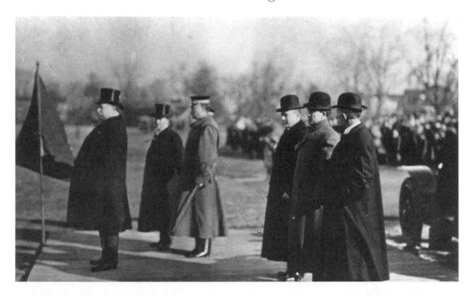

President William Howard Taft at the University of Illinois. *Courtesy Champaign County Archives of the Urbana Free Library.*

later when the question of merger again arose, the only surviving member of that earlier meeting—H.I. Green—was asked why no further meetings were held. He snorted, "Of course nothing further happened; there wasn't anyone who was for it."

One day in the late 1940s, a young assistant professor of zoology, Hurst Shoemaker, and an attorney, John Alan Appleman, were talking about the problem of doing something about Boneyard Creek. At the time, the Boneyard was an open, flood-prone and chronically neglected drainage ditch that flowed through the two cities carrying most of the storm water. The discussion ultimately came down to the difficulty of trying to deal with any problem that required joint action by Champaign and Urbana. Appleman suggested that there would not be a problem if the two cities were united.

Through the efforts of Appleman and Shoemaker and other progressives, the Urbana Civic Committee (UCC) was formed. Membership consisted largely, if not entirely, of people from Urbana who were, for the most part, affiliated with the university. Almost immediately, the new organization found a ready-made cause: merging Champaign, Urbana and neighboring rural school districts into a single unit. The problem was that all of the districts—rural and urban—had to agree. Although a majority of the voters

supported the issue, as well as majorities in both cities, one or more of the rurals did not. In spite of the defeat, membership in the UCC grew.

At its annual meeting in October 1951, the UCC membership resolved to go for a merger of the cities. The newly elected president of UCC questioned whether it was the time to "stick our necks out." Appleman responded by saying, "Either this is the tine or there is no time." Shoemaker added, "I have seen the question held up time and again for various reasons and I am glad it has now popped."

Appleman quickly had petitions printed that called for the merger of the two cities. At the time, only three hundred signatures were required from each city, but the attorney advised to have many more. The name of the united city on the petitions would be Champaign–Urbana. The petition drive was successful. Urbana city attorney Gene Weisiger was quick to present to his city council a lengthy memorandum opposing the merger. Responding, the Urbana Council directed Weisiger to "file legal objections and appear at the public hearing against the merger petition." It was not a favorable omen considering that the UCC leadership as well as membership was based in Urbana. In Champaign, Mayor Lafferty and the city commissioners took no public stance.

At the hearing, county judge Eugene P. Lierman refused to call the election; he ruled that the state statute was too vague and portions violated the state constitution. The judge was careful to state that his ruling was "not intended to express an opinion on the political and social advisability of uniting the two cities." He just wanted the constitutional question determined by the Illinois Supreme Court "before the expenditure of public funds" on a referendum. Both sides were equally determined to challenge the result in the advent of an adverse decision.

Before the Illinois Supreme Court, Attorney Green repeated the arguments of vagueness and constitutionality. He did mention the inconsistency in state statutes where merger required only three hundred signatures, yet it took a thousand to change the form of government. But that sort of inconsistency is par for the course for the general assembly. Then Green argued that the cities were not contiguous within the meaning of the statute, pointing to the two cemeteries on the south and a small portion of the university farms that partially divided the cities. Countering, Appleman's brief—in addition to pointing out the two mile common boundary—maintained "with all due respect it may be positively stated that all those in the cemetery are quite dead and those who are taken there in the future will be." Of course, no one lived on the university farm. How, Appleman argued, under such

circumstances, could either tract require municipal services? The court upheld the constitutionality of the merger statute.

There were no options left; the matter had to go to a vote. In the Urbana city elections that followed, all of the progressive Democratic candidates—led by political science professor J. Austin Ranney—lost. It was another bad omen for those in favor of the merger. Ironically, the antimerger partisans—mostly based in Urbana, the home base of the UCC—were quick to offer a list of twenty-five reasons for opposing unification. Most of the reasons were emotional such as "Urbana would be swallowed up by Champaign" and "most of the tax money would be spent in Champaign." But it was left to H.I. Green to go over the edge.

> *After 50 years of living in a community and getting in love with its people, habits and thrift, it is hard to control one's emotions. Those favoring merger haven't been here long enough to be grounded in the solid ideals of the community. Let's run our own show and ship. Let's have a campaign against merger that will stir them up to the threat to our heritage. You owe it to your children. You owe it to your family.*

Still, the early polls seemed to indicate a prima facie logic of a merger made sense to a majority of the people.

I was a senior at University High School at the time. The mother of a classmate was active in UCC, and in our senior English class during the sound-off sessions we were treated to a regular dose of promerger rhetoric. Years later I had the opportunity to talk with Hurst Shoemaker, a family friend, about the UCC and the merger campaign while preparing a research paper on the subject.

The Urbana antimerger committee offered a fifty dollar prize for the best slogan against the proposition. The winner was Keep Urbana Urban—Not Suburban. Other entries were Champaign–Urbana, Separate Communities—Inseparable Friends and To Combine Would Be Asinine.

The promerger forces were equally active. The difficulties in conducting business in a multijurisdictional environment and efficiencies of unification were probably their most effective arguments. Still, as time went on, doubts continued to be raised; during the course of the campaign those doubts gained currency. It would seem that when questions were raised, thinking gravitated toward the worst-case scenarios for a combined municipality.

Most of the people involved in the campaign, at least whose names were in the newspaper and whose addresses could be determined, were from

Urbana. One would have expected Champaign, being much larger, to have been much better represented. Further, polls showed promerger support was disproportionate among university academics, while opposition was overwhelming among the twin city business community. For a generally conservative Champaign–Urbana community, these numbers could not have offered much encouragement to the UCC.

When the votes were counted in the early evening hours of October 6, 1953, the outcome was just what the opponents had hoped for. In both cities the proposition lost by landslide proportions. In Champaign the margin was 70 percent to 30 percent; in Urbana it was 73 percent to 27 percent. Urbana mayor Glen Chapman thanked the "loyal people of our cities who have so generously given of their time and effort in defeating the merger." Champaign mayor Lafferty publicly retained his noncommittal stance. I also contacted the two former mayors when researching the 1953 merger effort. Chapman refused to be interviewed because I was on record as supporting the merger. Lafferty, on the other hand, freely revealed that he was quite pleased with the negative result.

The reformers did receive some consolation when, two years after the merger vote, Champaign voters approved a change from commission form of municipal government to council–manager. Apparently voters preferred having seasoned professionals directly overseeing city operations instead of four elected commissioners. In Urbana, nothing changed.

In 1978, in an effort to improve intergovernmental efficiency, the city councils of Champaign and Urbana established a commission to look into the matter. It was chaired by a recognized expert on local government, University of Illinois professor Sam Gove. After two years of deliberation, the commission came to the conclusion that the merger of the two cities would be the best answer.

Following the release of the commission's report that was drafted by Gove, the two city councils met in a rare joint session but declined to place the issue on their respective ballots. This necessitated petition drives in both cities. The Urbana Chamber of Commerce, true to its history, was quick to attack the Gove Report. Gove was asked to lead the campaign for merger, but he declined. Commission member Richard Foley and developer Clarence Thompson initially served as coordinators but declined to take permanent charge because they no longer lived in the cities. The commission then elected William Froom, a banker, to chair the effort. Froom, citing health reasons, subsequently bowed out as well. Finally, the chairman of the Champaign Chamber of Commerce, attorney Richard West, was persuaded to take charge.

We Call It Progress

When a sufficient number of signatures had been gathered, West, who was accompanied by former Urbana mayor Hiram Paley, filed petitions for the merger of the two cities under the council–manager form of government. With the opposition having quickly formed in Urbana and with a high level of public apathy, the campaign was off to an uninspired start. The debate raged along much the same lines as it did in the '53 effort. Of some interest was the fact that, in the meantime, Urbana had now become Democratic, and many of the liberal reformers in the earlier campaign now became some of the strongest opponents of merger this time around. Apparently they feared contamination from the more conservative predisposition of Champaign voters.

Opposing the promerger organization was the Committee for Independent Cities, which was chaired by attorney Philip Knox, grandson of the venerable H.I. Green. The blood must have run deep; again the margins of defeat in both cities were decisive. The only consolation was that the margins were modestly closer.

The victory of Ronald Reagan in the presidential tally in that election may have had a little to do with the result; the tragically flawed war in Vietnam and the prolonged Iranian hostage crisis had left the public disillusioned and unwilling to experiment. In the end, however, old habits die hard; tribalism is difficult to defeat. The struggle of the promerger proponents to find a leader embarrassingly resembled George McGovern's effort to find a running mate in 1972, and there were people who just did not wish to support the council–manager form of government. It is depressing to think that if Champaign and Urbana—with their largely homogeneous populations—cannot find common ground, what hope is there for peace between the Israelis and the Palestinians and similar conflicts elsewhere?

As a former participant in local affairs, I can offer only a few observations: After the failure of the two cities to jointly develop a new central library (each city is doing its own multimillion-dollar project), there seems to be little potential for serious cost savings that would be offered in a merger. It would, however, be easier to conduct both public and private business without the boundary line. Of at least equal importance, the cities of Champaign and Urbana, with their populations combined, would sit at the same table as Peoria and Rockford in the second tier of cities behind Chicago; currently—in their separate status—Champaign and Urbana have no clout statewide. With the state's premier public research university left to defend itself in a serious competition for increasingly scarce resources, this is a serious problem.

THE END OF APARTHEID IN C–U

Many years back, dear friend Daisy Holt Jackson related to me her experience in helping to integrate the public swimming pool at Crystal Lake Park in Urbana. The year was 1942. She had been one of a number of black, teenage girls who had been recruited to force the issue. It was hard for me to believe that segregation in a facility such as a public pool had been alive in Champaign–Urbana. It was a story that needed to be told, and I encouraged Daisy to write it up. "You write it up," she countered.

Things rested there until Daisy's daughter, Gina, a retired career army officer, returned to Champaign and ran for city council. Under the belief that I could offer her some advice, Daisy had Gina get in touch with me. I was more than willing to help, but at our meeting I brought up her mother's integration story and encouraged Gina to write it up. Gina declined, saying, "You write it up." Both Gina and Daisy believed the story should be told, and I was flattered that they believed such a great story should be entrusted to me.

With a military-like follow-through, Gina appeared with newspaper clips from 1942 that gave sketchy accounts of what happened. I also called Daisy to get more of her memories of those events. But Daisy was in her eighties, and the event occurred when she was a teenager; memories fade. She did

The original Crystal Lake pool. *Courtesy the author.*

Daisy Holt Jackson.
Courtesy Gina Jackson.

remember that the integration effort was led by the wife of a University of Illinois faculty member; that lady was Mrs. B.F. Timmons, chairman of the social action committee of the First Congregational Church of Champaign.

In an effort to learn more, I called Erma Bridgewater who, in her nineties, is the chief living repository of black history in Champaign–Urbana. She grew up in Champaign on West Ells Street. But being a few years older than Daisy, Erma was not involved in the integration of the pool. While she was also unable to provide details of that event, she did tell me where black youngsters could swim before the pool became available. "We swam in the ditch," she said. The ditch was the Saline Creek that flows south, just a stone's throw to the west past the park pool.

The other source, of which I was sure would mention the details of the pool's integration, was the minutes of the Urbana park board. A call to the offices of the Urbana park district was most disappointing. Prior to having

Erma Bridgewater. *Courtesy Erma Bridgewater.*

an office location, the board met in the offices of its attorney and that was where the records were stored. A fire there in the late forties destroyed all of them.

The *Courier's* August 16, 1942 edition carried the following announcement regarding access to the pool: "Crystal Lake park pool will be opened to Negroes of the community for one week, commencing Monday, the first time in history Negroes have been allowed to use the pool. Park district directors decided recently, in response to many requests, to make this change in regulations."

The pool was to be opened exclusively to blacks for one week only at the end of the season. Once the decision of the park board had been announced, Mrs. Timmons put out a call for donated swimming suits for black children to be dropped off at Swannell's drug store in Champaign or at Knowlton and Bennett drug store in Urbana.

Unfortunately, the details of how the social action committee proceeded and the specifics of the roles of Daisy Holt Jackson and her brave companions

appear to have been lost to history. The pool presumably opened on a fully integrated basis starting with the 1943 season, but there was no mention of it in the coverage of either the *Courier* or the *News-Gazette*. When I began using the pool in the mid-1940s, it was integrated.

Mirroring the pool situation was the segregated USO facilities for white and black soldiers during World War II. The white USO was situated in the old Champaign High School building just north of the old post office (the Springer Building) on Randolph Street. Erma, who was married to a serviceman, identified the location of facilities for black servicemen as the basement of Lawhead School, across Fourth Street west from the Douglass Center. Both buildings have long since been razed. The USO operations ended well before President Harry Truman, in his Executive Order 9981 issued July 26, 1948, directed that the armed forces be integrated as soon as possible.

Erma, who was the honored guest at the 2007 annual meeting of the Champaign County Historical Museum, also related the segregation that existed in local movie theaters.

At the Virginia, we were allowed to sit in the balcony in the last two rows on the east side. If the usher was not looking, we moved forward. At the Rialto, we could sit in the last few rows in the balcony; at the Park (now

The Champaign USO Club. *Courtesy the author.*

the Art Theater), we were allocated the first two rows—a neck-straining experience; and at the Orpheum, we could sit in the last two rows on the first floor.

Erma, who went to the University of Illinois, also related that there was no place for blacks to eat on campus and, except for north-end establishments, barber shops run by both blacks and whites and operated in downtown and campustown served only whites. The whites-only policy in local shops ended in the face of student agitation in the 1950s. Unfortunately, these instances represent only a part of the disadvantages black citizens operated under during those years.

We have come a long way in the past five to six decades. The shame must remain that such official and de facto discrimination ever existed in the cities of Champaign and Urbana.

THE MAYOR, THE MEGALITH AND THE ACTIVIST

The story of the Lincoln Megalith began innocently enough; it came about as a result of an effort to exploit the presence of Abraham Lincoln in Illinois and was promoted by Illinois governor Otto Kerner. Champaign attorney Lewis Tanner, chairman of the Regional Tourism Council and the Mayor's Committee to Encourage Visitors to Champaign, was quick to take notice. It was his idea to erect a monument in downtown Champaign and locally commemorate the presence of the sixteenth president during his circuit-riding days. The idea was to put Champaign on the Lincoln Heritage Trail and draw tourists.

Lincoln had indeed been present in what became the city of Champaign in the days before his rise to fame and historical immortality. He rode through on his way from Springfield to Urbana and beyond to Danville while on the circuit. Among the various locations in the city in which Lincoln has been identified are the Baddeley (later the Joseph Kuhn) home, located where the Jefferson Building stands today; the Doane House, a combination train station and hotel on the east side of the Illinois Central tracks in the vicinity of the Champaign Police Station; and the Goose Pond Church, formerly located just a short distance to the north where Lincoln had spoken on occasion. Lincoln would certainly have seen the Cattle Bank, across First Street to the east, which he would no doubt have had to pass on his way to Urbana and the courthouse. The building, then a new—though short-

Emerson Dexter. *Courtesy T.J. Blakeman.*

lived—banking enterprise, survives to this day at the corner of University Avenue and First Street.

To his credit, Tanner was quick to pursue the enterprise. He enlisted Urbana architect T.J. Strong to design the monument. It had a shaft that was nineteen feet tall, six feet across and two feet deep and was made with large, rectangular slabs of Bedford limestone. The monument had Lincoln's profile in bronze on its face and an eternal flame. (The latter seemed to be the trend at the time, which occurred less than a year after John F. Kennedy's death and burial.) The estimated cost was set at $20,000 to $25,000, which was reduced through donated services; University of Illinois professor William Fothergill, who sculpted Lincoln's profile, was among those who helped.

Fundraising began with a ten-dollar-a-plate dinner at the Champaign Moose Home for an anticipated six hundred people; it was cosponsored

by the Champaign Rotary Club, Kiwanis Club and B'nai B'rith Lodge. (Participation of the latter group could well have been due to the involvement of Isaac Kuhn, an influential Jewish businessman and Lincoln buff who grew up in the Baddeley home where Lincoln reportedly had stayed.) Additional funds were raised by the sale of Lincoln souvenir dollars. The dollars pictured the profile of Lincoln on one side and the monument on the reverse. In the end, the total out-of-pocket cost for the monument was set at $7,000.

I recall being highly skeptical that the monument would draw visitors but did not put my thoughts to writing at the time. That wasn't so for Albert J. Rutledge. In a letter to the editor he opined, "The Lincoln Monolith [*sic*] is an unimaginative work of no aesthetic value and is further degraded as a piece of art by the inclusion of such stale gimmicks as an eternal flame; why would a touring family detour in its trip to New Salem and Springfield for a ten-second glance at this meaningless marker of municipal pretense?"

In a letter written years later recalling my view at the time, I wrote that "anyone savvy about the business should know, a monument does not a tourist draw, particularly an uninspired monument at that." It was like the

The relocated Lincoln Megalith. *Courtesy Jeanette McCollum.*

so-called "pedestrian malls," a desperate act to save weak downtowns. Like those malls, it did not work.

With the exception of the bronze profile of Lincoln, work on the monument was completed in time for the dedication on May 28, 1964. A fiberglass copy of Lincoln was a temporary substitute. (The copy was given to the county when the bronze sculpture arrived later.) Governor Otto Kerner was scheduled to be the guest speaker. In the meantime, a subplot was developing: a campus student group involved in civil rights activities had contacted the governor's office to request a meeting; the group wished to voice its concerns about what it alleged to be the racially discriminatory practices of local Realtors. Without question, Champaign at the time was a highly segregated community with respect to housing. The cause was largely economic, but a deliberate policy of realtors cannot be dismissed entirely.

The group attempted to talk with the governor at the airport but was unsuccessful. The motorcade offered an inauspicious beginning to the event when the motorcycle police escort was involved in a crash on the way into town. Nevertheless, the entourage arrived at the monument at the corner of Main and Hickory, just west of the W.T. Grant department store. The community had pulled out all stops with the presence of the Air Force Band of the Midwest and a large crowd of citizens. Also present was the civil rights contingent, which was determined to be heard. Against the Grant Building they spread a sign that read "Lincoln Assassinated in 1865—Realtors Assassinate Open Housing in 1964." They sang, as loudly as possible, *We Shall Overcome* and *Black and White Together* but were drowned out by the band playing the national anthem. The governor spoke, and the band finished up with *God Bless America.*

Following the ceremony, the notables adjourned to Tilden Hall, a short distance across Neil Street, for a dinner; the protesters followed. There they were able to speak briefly with the governor, who then turned the group over to his press secretary. As the protesters were earnestly pressing their case, Champaign mayor Emmerson Dexter (Deck to his friends) walked up and told the press secretary: "This is no civil rights meeting, it is a reception for the governor; you don't have to do this if you don't want to." The leader of the group, graduate student Gerald K. Weiss, "leaped up" and confronted the mayor, not knowing who he was. "You are being very rude," Weiss charged. Dexter, obviously annoyed with the multiple disruptions by the group, "decked" the student. "I just hauled off and punched him in the jaw real good," recalled Dexter.

At this point, the accounts diverge. Weiss contended that the blow was without reasonable provocation. Longtime local politician Leo Pfeffer, standing nearby, claimed that Weiss shoved Dexter. Chicago attorney Ray Harth, who was with the civil rights group, accused Pfeffer of trying to supply Dexter with a defense. Weiss demanded that Champaign police chief Harvey Shirley, who was standing nearby, arrest the mayor. "I did not see anything," responded the chief. "You will have to get a warrant from a judge." Weiss, after a trip to Burnham Hospital for an X-ray, spent much of the remainder of the day searching out a magistrate. In the end, Dexter was not arrested; he was merely issued a notice to appear. Years later Dexter told me, "I was amazed; there were lawyers who called from as far away as Bloomington and Danville willing to defend me for nothing!"

The following day, the *Gazette* report of the day's events led off with "Governor Otto Kerner dedicated a Lincoln Megalith in downtown Thursday afternoon on a day that had a crash beginning and a smash finish." It was indeed a good story. The colorful mayor was tried but acquitted. An element of controversy persisted, however. Who would raise and lower the flag associated with the monument on a daily basis? Dexter instructed the police department to perform the function. But city manager Warren Browning said "it isn't police work." In the end, Deck had it his way. From a policy point of view, I would have agreed with Browning that it was not police work but, after all, Dexter was the chief elected official of the city and that should count for something.

THE MEGALITH

A Postscript

The years had not been kind to the Megalith. Its flame had been extinguished, shut off as a conservation measure in the 1970s; the window that had protected it had been broken; and it attracted some graffiti. Joan Severns, mayor from 1979 to 1983, complained about the condition of the megalith but nothing happened. In Jim Dey's column in the *News-Gazette* on March 17, 1990, I was quoted as characterizing the monument as "a monstrosity, just a neglected and not very attractive remnant of somebody's better idea in the downtown." Tanner—by this time elderly—was somewhat distressed by my intemperate remarks and commented: "I go by it every day when I go to the post office; when I see vandalism to it, it makes me mad. But there's nothing I can do about it."

Former Champaign
mayor Joan Severens.
Courtesy T.J. Blakeman.

Dey's column was picked up by Tom Phillips of the *Pana News-Palladium*. Phillips's column read in part: "Twas dedicated in May of 1964, with the expectation that this monument to our 16th president, standing 19 ft. tall, would among other things boost tourism. It has apparently been left to deteriorate." It is described by a Champaign columnist standing "as a monument to an idea that went wildly wrong."

The next year Dey, in yet another column, again addressed the situation of the Megalith. "But the reality of vandalism, a weak commitment and a location in a declining downtown center took its toll."

But the fate of the Megalith was ultimately determined by another event. In 1987, a fire destroyed most of the block at the northeast corner of Main and Hickory; the exception was the Grant Building, which stood vacant and derelict. For the next two years the facades of the destroyed buildings were shored up as various redevelopment schemes were proposed. I was supportive of the effort to preserve the nineteenth-century facades if

it were possible, but it was not meant to be. Finally the city—its patience exhausted—demanded that the eyesore be removed. The city acquired the properties, including the Grant Building, and the block was cleared.

In light of the constant need for parking, the city council approved a plan to convert the area to a parking lot. The plan also anticipated the alignment of Main and Church Streets at a later date. All this put the Megalith in the way of progress. The monument had been donated to the city, so city officials were in a position to decide its fate. There was no inclination to simply bulldoze over the Megalith. At this time, I was in discussion with officials of the park district regarding the return of the old downtown fountain from Scott Park. It had been removed to Scott Park earlier than anyone could remember. With the loss of the Grant Building, I wanted the fountain restored and put back to define the corner of what had once been the center of the old downtown.

It was decided that the Megalith, with the blessing of Mr. Tanner, would be taken down and reconstructed most tastefully in West Side Park, albeit much reduced in stature. And, mercifully, there was no eternal flame. The fountain, nearly in a state of collapse, was dismantled, restored and re-erected within a few feet of its original location in the downtown. Both projects were made possible with donated funds. Ceremonies were held at the rededication of both monuments. The event for the Megalith was held on August 22, 1992, with former mayor Emerson Dexter, the then current mayor (me), park board president Newton Dodds and parks general manager Robert Toalson in attendance. The guest of honor was Lewis Tanner who had helped raise funds for the move and restoration. Given the civility and contributions of Mr. Tanner throughout the process, I felt more than a little embarrassed for my earlier public statements. Hopefully, I learned something.

EVOLUTION OF A DOWNTOWN

I count myself lucky to have been old enough to remember the downtowns of Champaign and Urbana as they were from almost the beginning of the twentieth century, especially before the great changes after World War II. While I did not live close to either of the business districts, at one time or another in the late '40s through the early '50s I carried both the *News-Gazette* and the *Courier* newspapers. After Saturday morning collections from customers I then went to the downtown offices of the papers to pay my bill. (Paper boys—no girls back then—were independent contractors, not

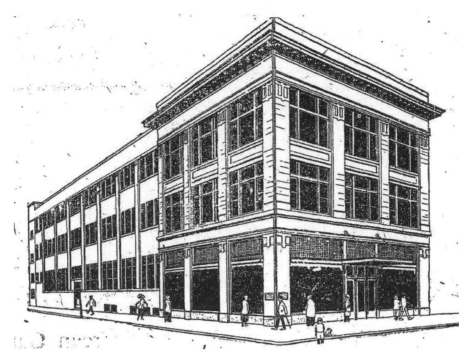

Willis Store, before 1945. It was the original building, which was remade into the J.C. Penney store and finally the Stevick Building. *Courtesy T.J. Blakeman.*

employees of the newspapers. I guess that it was one way of avoiding child labor laws.)

In the age before automobiles in the early twentieth century, virtually all commercial and social activities occurred in or near the downtowns; this included general retail, food markets, banking, professional offices, government, theaters, bars, restaurants, churches, lodges and hotels. Most of the general retail in Champaign was locally owned. Robeson's was a real department store—it even had an escalator; Kuhn's was as fine a clothing store as one could find south of Chicago. I was always intrigued by the pneumatic system of sending the bill for the purchases, with the cash payment, to the centrally located cashier and getting it promptly returned with change via the same route. There were no credit cards in those days. Other locally owned stores included Sholem's, Kaufman's, Sandwell's, W. Lewis, Piggly Wiggly (Eisner Grocery Co.) and many others. There were some national retailers as well, including Sears, Penneys, Woolworth's, Kresgee's and the A&P. The main area post office—a grand building—was

in the immediate downtown area, and the Champaign Public Library was nearby.

The banks were locally owned and represented old money in the community. The First National Bank stood out. Largely the creation of Benjamin Franklin Harris, this massive classical-revival structure at the corner of Main and Walnut was more than enough to assure customers that their money was safe. It had a two-story grand lobby—one that was worthy of a big city—which was subsequently destroyed to shoe-horn in a mezzanine floor. The Trevett-Mattis Bank, though smaller, also had a fine Roman front. Champaign National Bank, as well as Commercial Bank that was east of the tracks, was also locally owned along with a number of smaller financial institutions.

The opera houses had given way to vaudeville and movie theaters. The Park was one of the earliest, having been opened in 1913. In the years of my youth it was highly popular with the kids; there were great Saturday matinees for twenty-five cents. And for those who were younger than twelve or could pass for that age it was only five cents for the bus ride downtown. The other popular theaters included the Rialto, Orpheum and Virginia. The latter two were specifically designed to accommodate live vaudeville performances as well as movies.

The establishment churches also were clustered near the Champaign downtown. The First Methodist, First Presbyterian and First Baptist were

Penneys, circa 1955. *Courtesy T.J. Blakeman.*

within a block or two of the commercial area; Holy Cross was just to the southwest. The lodges were also downtown. The Masonic temple, a majestic classical-revival structure, still stands at the corner of Randolph and Hill. Also located in the downtown were the Elks, Moose, Modern Woodman, Odd Fellows and probably a few more. There were also the hotels: Tilden Hall (formerly the Beardsley), Hamilton and later the Inman. Only the Inman survives today; it is an assisted-living facility listed on the National Register of Historic Places. It was touted as the first fireproof hotel in Illinois south of Chicago.

For much of the first half of the twentieth century the pace of change was slowed by the First World War and the economic downturn in the years that immediately followed. Then, in 1929, the bottom fell out of the nation's economy. In 1941, World War II began to raise the country out of the Great Depression, but the resources of the nation were focused on winning the war. Thus, for some two and a half decades, which happened to be my formative years, the downtown environment remained relatively static.

The first years following the war were a boom period. Pent-up demand filled the stores with shoppers. During the weeks prior to Christmas one would almost have to fight for a place on the sidewalk, and the stores were crammed. A number of vintage downtown brick buildings received sleek new facades of sheet metal or pasted on glass blocks. While these treatments detracted from the character of the business district, the real assault began in the late 1950s when the Swanell Drug building—a stately, three-story Italianate structure on the northeast corner of Main and Neal—was torn down to build Grant's Department Store. Other buildings were taken down to make way for off-street parking. In spite of the changes, the general appearance of the downtown was good. Most business owners took a fair amount of pride in how the sidewalks looked in front of their establishments. I have vivid memories of George Sandwell sweeping the sidewalk in front of his business at the corner of Logan and Walnut Streets.

Fires have always been a threat to older buildings in downtown areas. The first great downtown fire that I remember was the 1948 fire that destroyed the Flatiron Building that anchored the west end of the business district in Urbana. There was genuine community-wide mourning for the loss of that building. We drove over the following morning to view the smoldering ruins as many hundreds of others also did. Almost four decades passed before the next major loss of downtown vintage buildings: the 1987 fire that destroyed the entire business block at One Main in Champaign. Most recently, in 2008, a fire destroyed the Metropolitan Building at the corner of Church and Neil Streets.

The Stevick Building, which once housed the Willis Store. *Courtesy the author.*

In 1959, a serious harbinger of things to come for downtowns occurred with the opening of Country Fair Shopping Center, northwest of the intersection of Springfield and Mattis. While never a major threat in itself, Country Fair represented a new concept in retailing—the regional shopping center. These developments were usually situated in the outskirts of medium-sized cities with acres of parking, an anchor store or two and a multitude of smaller retail enterprises. Downtown Urbana, which was never as large or successful as downtown Champaign, sensed an economic threat and decided on a dramatic move. In 1964, the city developed a very large, enclosed shopping mall with ground zero being at the intersection of Green Street and Broadway, obscuring the wonderful façade of the Urbana-Lincoln Hotel. Carson, Pirie, Scott & Co. was enticed to move in as the anchor store. The development took out a six square block area with plenty of parking. I recall feeling at the time that the blockage of Green Street—a major east–west street—was a mistake.

In Champaign, the downtown commercial interests felt the need to respond by providing a huge increase in parking and creating a pedestrian friendly area. This concept was adopted by scores of other cities around the nation. In 1966, the Flatiron block, between Neil and Hickory, was razed for

This page: Champaign City Building, the spiritual center of downtown Champaign, as it was originally built. *Courtesy the author.*

parking along with virtually the entire area behind the Sears and Penneys stores east to Walnut and north to Washington Street. Neil Street, the main north–south thoroughfare in the downtown, was blocked off from Main to Taylor for a pedestrian friendly area. (Another bad idea, I thought.) All this was in a vain effort to keep Sears and Penneys from moving to the regional shopping mall being developed off Neil Street just north of Interstate 74.

Within a year, in spite of the huge public investment in downtown parking, both stores moved to Market Place Mall. In the end, the move precipitated the exit of major retail from the downtown; smaller stores then followed the big stores. It was not that the large national chains had anything against Champaign or any other of the hundreds of downtowns where such evacuations occurred. It was just the trend to move to the interstates and haul in customers regionally with easy access and acres and acres of free parking.

Flatiron Building.
Courtesy the author.

Close behind, the major movie theaters closed beginning with the Rialto and followed by the Orpheum and the Virginia. The only anchors left downtown were the big banks, city government, the newspaper and Christie Clinic. Robeson's Department Store struggled for a few more years but closed after being in business for over a hundred years. It was an 8 to 5 downtown; after that, the place just dried up.

Using tax increment revenues, the City of Champaign began work to improve the appearance the core business area. Champaign mayor Robert Dodd made it his mission to reopen Neil Street at city expense. The pedestrian mall (which should never have been built in the first place), part of the miracle answer to save the downtown, had been an expensive failure. The only argument was who should pay: the city or the property owners who had argued for the mall in the first place. In the end, the mayor had his way, which was probably the only expeditious way to get rid of the mall.

The city persevered with streetscape improvements and offered economic incentives for upgrades of older buildings. Also, there was a provision for Class A liquor licenses, which were limited in number, for major renovations of buildings. To save the grand but threatened Virginia Theater, the city supplied $500,000 in city funds for its purchase from an out-of-town owner. This began the long-term upgrade of that wonderful facility. Within a few years, it became the property of the Champaign Park District along with

Urbana-Lincoln Hotel. Along with the courthouse, this was the most notable building in downtown Urbana. *Courtesy the author.*

the former downtown post office; the latter became a well-used recreation center. By the mid-1990s, the downtown had again become a destination with specialty retail, street cafes, coffee shops, restaurants and an amazing variety of nightlife. Major retail, however, probably will never return.

The return to health of Champaign's downtown has been a real success story. With suburb after suburb sprawling across miles of farmland and burgeoning bedroom communities, the city was in real danger of losing its character. As one cynic said of Los Angeles, "There's no there, there"; Champaign was able to preserve more than a little of there, there.

It should be noted that the north–south Interstate 57 was originally planned to run east of Champaign–Urbana, not west. Had that happened, Market Place Mall probably would have been built in Urbana with that city profiting from the large sales tax revenues from the development. Champaign was just lucky.

THE COKE PLANT

One of my classmates at South Side Elementary School in Champaign was Ann Overshiner. Her father was the manager of the local Coca-Cola bottling plant. Because of the connection, our third-grade class took a field trip to see the plant in operation. The building occupied a conspicuous location on South Neil, a major north–south street. It was a fine art-deco building dating from the late '20s. A long window on the facade facing the street showcased the line of empty Coke bottles as they moved from the bottle washer to the machine where they were refilled and capped.

Even though all of us had passed the plant many times, the actual visit was quite exciting. For me and probably for most of my classmates it was the first time we had seen anything akin to an industrial operation. It seemed that the machines did everything. At the end of the tour, we all got to drink a bottle of Coke right off of the bottling line. In those days, the soft drink bottlers used returnable bottles that had a two-cent deposit to ensure their return. It was always fun to find an empty that someone failed to return. It was money in our pockets.

As the years passed, the line of bottles disappeared from the window. That was about the time that the other soft drink bottling operations began to shut down. The returnable bottles disappeared as well. While I missed seeing the line of bottles passing across the front of the window, I was further concerned about the change in the new containers; the drinks started to come in cans that were advertised by the industry as "convenience packaging."

The Coca-Cola bottling plant today. *Courtesy Jeanette McCollum.*

The plant at first simply became a distributing facility. But distribution alone no longer required so large a facility, so the distributor left the fine brick building for smaller quarters elsewhere. The building became a warehouse for car parts, and the window that formerly carried the line of Coke bottles then offered a fine view of mufflers and tailpipes. Before long the building became empty.

The environmental movement began to heat up about the time the bottling operation ceased. A professor at the university and his students did a study of the relative energy use of refillable, returnable containers versus the so-called convenience throwaway packaging. The results indicated that the new packaging placed much greater demands on energy use than the old. It became a significant environmental issue. Oregon voters responded by voting to impose a deposit on beverage containers mostly to deal with the litter problem caused by the throwaways; excessive energy use and recycling were also reasons. A number of states have since followed Oregon's lead.

That, however, did not help the empty Coke plant. Redevelopment of such a large facility would not be easy. Having seen the loss of many significant buildings for parking lots and tasteless new construction, I proposed to the owner that the city might offer an additional Class A liquor license, as an

incentive should he redevelop the building and preserve the historic integrity of the exterior. To limit the opportunity to the Coke plant or a building of similar size the following additional terms were made:

(1.) The facility had to be larger than twenty-five thousand square feet in size.

(2.) It had to have been built prior to 1945. This provision was made to exclude newer buildings; no significant buildings were built either during the war years or the Great Depression. Thus, for all practical purposes, the building had to be built prior to 1930.

(3.) Current city life-safety codes had to be met.

A later owner took the bait, redeveloped the building and successfully speculated on its use as an entertainment venue with a liquor license. It should be noted that redoing older buildings to meet modern building codes is not cheap. The city subsequently employed the same strategy along with other incentives for smaller, older buildings downtown. While much of the historic building stock has been lost in the older areas, much has been saved. Alas, no progress was ever made on a statewide beverage container deposit law in Illinois.

Chapter 8

The Human Side
of Place

SHAKERAG

Timber Rats and Prairie Dogs

Shakerag must rank as one of the stranger names in Champaign County. Over the years, the name has denoted a specific location in south-central St. Joseph Township, specifically adjoining sections twenty-seven and thirty-four. Yet it has never appeared on any county map. Shakerag isn't even mentioned in *Illinois Place Names* as ever being associated with the county though the book lists three extinct locations with that name in Bond, Hancock and Williamson Counties. Closer to home, there is a Shakerag Road in neighboring Vermilion County.

The Alexander Bowman 1863 map of the county shows nothing unusual about the sections with each having some six landowners. However, by 1893, sections twenty-seven and thirty-four have twenty-two and thirty-nine landowners respectively—many more than neighboring rural sections. Even after the turn of the century, in 1913, the number remained disproportionately large even though the total number of landowners had declined.

Such numbers lead one to suspect that a dispersed settlement developed in the Shakerag area during the latter quarter of the nineteenth century and persisted into the twentieth. Accounts of older residents of St. Joseph and Sidney Townships tend to confirm such an assumption. It seems the focal point of the settlement was the area adjoining the Salt Fork River in the vicinity of the old and now long-gone iron truss bridge. The span was known as Shakerag Bridge.

An 1893 map shows a school a quarter of a mile east of the bridge on the south side of the river. There was also a church. Imal Lovingfoss, who attended services there, remembered it. "It was a one-room church with a steeple, standing west of the school; the river [just north of the church] was used for baptisms." Both church and school were gone by 1920.

The only story surviving that explains the origins of the name Shakerag comes from Ruby Rogers West. From what she heard years earlier, the people of the Shakerag community were poor though they apparently knew how to have a good time. Country dances were held at the school and, as the people danced, so it was said, their tattered clothes fluttered in the breeze—hence the name Shakerag.

Often these affairs included box-lunch socials. Luther Mumm, a "yup and nope" retired Sidney farmer who attended them as a young man, recalled that the young, unmarried women would prepare box meals in gay wrappings to be auctioned off to the young, unmarried men. The latter tried to buy the meals prepared by their respective sweethearts. While the meals were not marked, the gals found various ways to let their guys know who prepared what. Luther laughed while remembering that when the other men found out someone was after a particular box they would bid the price up.

The young men from Sidney and the surrounding flat lands who attended the socials referred to their counterparts from the wooded area around Shakerag as "river rats." The latter retaliated by labeling the former "prairie dogs." These were not terms of endearment, and fights were not a rarity at the socials.

Perhaps the best surviving expression of the prejudicial feelings harbored against the folks then living in the timber along the Salt Fork comes from the May 30, 1903 edition of the *Urbana Daily Courier*.

> *David McCracken, a representative of the jungles of "Shake-Rag,"*
> *according to Magistrate Sims, appeared before the stern bar of justice*
> *in the Urbana police court yesterday morning to tell why he was drunk.*
> *David explained that the ignominy attached to residence in Shake-Rag*
> *was such that he tried to drown out the thought by frequent potations.*
> *Squire Sims fined him $3.00 and costs, which the Shake-rag denizen paid*
> *and returned to the jungles, swearing to be true to Shake-Rag and leave*
> *Urbana alone hereafter.*

Alas, nothing remains of old Shakerag. Even the fine old iron truss bridge has been replaced with a characterless concrete deck span.

THE GREAT SHOOTOUT

While growing up I thought Champaign–Urbana was a quiet place; nothing exciting ever seemed to happen here. That was largely because I grew up in what was then known as the southwest area of Champaign. In 1937, the year of my birth, it was a mile and a half southwest of downtown. Champaign was a railroad town, and there were such things as prostitution and gambling still going on. During Prohibition there were illegal watering holes, all in and around the downtown area. Also, the city was highly segregated with most black citizens living north and east of downtown; the west-enders were just not confronted with the racial problems that existed. But wild things did happen.

One such occurrence unfolded in the late evening and early morning hours of September 27–28, 1928. Two bandits from Chicago found themselves in Mattoon, Coles County, south of Champaign. At around 11:00 p.m., apparently in need of transportation to the big city, they approached a parked Nash sedan occupied by Fred Mock and his girlfriend. Initially appearing intoxicated, they commandeered the automobile at gunpoint. After taking what valuables the couple had, the bandits forced Mock to drive them through the business district as well as residential areas. Mock thought that they were looking for a place to stick up.

A police Buick, circa 1930. *Courtesy Zane Ziegler.*

After awhile, they came upon a second car—an Oldsmobile—where Albert Bevel was at work changing a flat tire. After forcing Mock to stop, the taller one of the two bandits got out, walked over to Bevel, stuck a .45 automatic pistol in his ribs and took his money and Big Four Railroad paycheck. Bevel was forced to complete the tire change and, with an armed bandit in each car, the drivers were forced to drive some distance out into the country. At that point, the bandits asked how much gas was left in the Nash. Mock said, "About two gallons." The same question was directed to Bevel who answered, "About the same." Suspicious and not taking his word for it, one of the bandits checked Bevel's gas gauge and found the tank to be full. The other bandit disabled the ignition system of the Nash. Before leaving, one of the bandits returned the ninety cents he had taken from Mock's girlfriend. They started off with Bevel's car, but stopped soon after. The bandit who had taken Bevel's pocket watch asked him if he used it on the railroad. Bevel said yes and the bandit returned it to him. Even bandits can, on occasion, be chivalrous.

The bandits felt confident that neither Mock nor Bevel would be in a position to report the crime so early in the morning and so far from town with a disabled car. Bevel, however, knew of a grain elevator just a short distance away and ran off to sound the alarm. Acting quickly, the local police alerted all law enforcement agencies within a fifty-mile radius. Presumably operating under the assumption that the bad guys might be headed to Chicago, two Champaign police officers, Patrolmen Dempsey and Hendrickson, lay in wait along South Neil at Charles Street in the department's riot machine, a speedy Buick Sport touring car. At 1:15 a.m., their quarry was in sight, having just quickly passed the darkened police car.

With Dempsey at the wheel, the Buick roared into hot pursuit. The chase was on. The Buick caught up with the bandits in Bevel's Oldsmobile at Healey Street where Hendrickson ordered the bandits to stop. While he was reaching into the back seat for his sawed-off shotgun, a pistol round flew past Hendrickson's head. The driver in Bevel's car accelerated and soon exceeded sixty miles per hour. Hendrickson emptied his sawed-off shotgun into the bandit's car. Dempsey, also out of ammo, managed to reload his .38 automatic while driving abreast of the bandits. As both cars raced past the City Building at University Avenue, Patrolmen Charles Cole and Clyde Davis heard the shooting and fired several rounds at the bandits. (Clyde Davis later served as the chief of police in Champaign.)

The chase continued to the point where North Neil Street ended. Unable to make the turn, the bandits' car crashed through a fence and came to a

halt. Both men jumped out and began running. Dempsey and Hendrickson, with neither wearing the steel vests provided to them by the department, were in hot pursuit; Hendrickson was in the lead. Dempsey brought down the short bandit and Hendrickson was sure that he had hit the tall guy, who stumbled twice but was able to escape when Hendrickson's gun jammed. An extensive search the remainder of the day and the next failed to locate the tall bandit.

The captured bandit was wounded in a number of places, with the most serious injury being a shattered thigh. He was taken to Burnham Hospital and was conscious enough to be questioned by the police. The little information that he was willing to offer was in "a broken dialect that [was] characteristic of Italians." "Haven't anything to say; don't want my folks to know; I played the game and lost," he said. When asked by Sheriff Chester Davis what he wanted done with his body should he die, he replied: "I don't care what you do with it." "If your partner is found dead, what should be done with his body?" Davis asked. "That's up to you, I don't care what you do with it."

The questioning continued:

Davis: "Won't you tell us your name?"

The bandit: "I'm not putting out a thing."

Davis: "Have you ever been in custody before?"

The bandit: "That's for you to find out."

Deputies from Coles County arrived the following day to pick up defendant John Doe. Also, Albert Bevel was in the city to recover his machine. It was in poor condition considering the adventures of the previous day: all of the glass had been shot out; one of the front wheels was bent in; and the body was pock marked with some thirty bullet holes. That was not the only story regarding the shootout. The tall bandit, though badly wounded, came upon Frank Mathis, a young farmer whose truck was stuck in a mud hole. In spite of his injuries, he somehow helped Mathis free his truck from the mud. He then produced a pistol and ordered Mathis to drive him to Chicago.

It was during the trip that Mathis discovered the extent of the man's injuries. His shirt, which was torn to rags, was used to bind multiple wounds on his right arm. He groaned every time the truck hit a bump and was spitting out blood. In response to Mathis's inquiries about the wounds, the bandit responded that he had been shot in a gambling house in Champaign while shooting craps. (At the time, Mathis was unaware of the great shootout.) At 1:15 a.m., at Forty-ninth and Western Avenues in Chicago, the bandit spied a cab and ordered Mathis to let him out. Mathis turned his truck around and promptly headed back to Champaign County. The cab followed him

to the city limits of Chicago, presumably to make sure he did not report the incident too soon. The young farmer drove the entire 147 miles back before bringing the incident to the attention of the authorities.

What happened next after this rather amazing event seems surprisingly modest: The next mention of the affair was in the November 12 *News-Gazette*, when a Coles County grand jury returned three indictments against John Doe; the bandit was still refusing to divulge his name. Of the indictments, two were for stealing the two cars and one for the holdup. Considering what had transpired, it seemed a rather lame response by the criminal justice system. Who can say nothing ever happened in Champaign?

THE BUSEY HOUSE ROBBERY

I had long ago noticed the very large frame house that occupied half a city block between West Green and Elm Streets in Urbana. I was often in the area because a high school friend lived next door to the west. It was only many years later that I became acquainted with Garreta Busey, the elderly lady who lived there. Garreta was the great-granddaughter of Matthew Wales Busey, a notable county pioneer; granddaughter of Simeon H. Busey, one of the founders of Busy Brothers Bank; and daughter of George W. Busey, also a banker. Garreta went to Europe to be a volunteer nurse during World War I, never married, returned to her hometown to teach English at the University of Illinois and lived on in her parents' home after they died.

It was through my interest in local history that I took advantage of an opportunity to meet her. I spent more than a few evenings listening to her accounts of family lore and history. One evening at dinner with Garreta in the Busey home, she related the story of an armed robbery that occurred at the house many years earlier on November 20, 1928. At around 6:00 in the evening, George Busey and his wife, Kate, daughter Garreta and two female guests, Mrs. Henry M. Dunlap (wife of a state senator) and Mrs. Meta Chambers, were at dinner. Two bandits entered the house suddenly through an unlocked door to the porch.

One of the two men, tall and slender, had a handkerchief across the lower portion of his face and presented a revolver. He demanded the family and guests place their hands on the table. George Busey, who initially thought the robbery was a gag, declined. The bandit then started around the table and looked for rings or other jewelry on the hands and wrists of the ladies.

Garretta Busey at about the time of the robbery. *Courtesy Champaign County Archives of the Urbana Free Library.*

According to Garreta, the women had the presence of mind to slip off their rings and kick the items under the table. By this time, George Busey was convinced that this was no joke and placed his hands on the table as well. When the bandit came to the banker, he demanded that he hand over his wallet; George complied. It contained only five dollars, which the bandit extracted before handing it back.

According to a newspaper report, when the ladies appeared to be nervous—understandable under the circumstances—the tall bandit assured them. "Do not be frightened," he said. "I am not going to hurt you." He then sent his accomplice, described as "low, rather heavy set and gruff in manner," to search the upstairs for valuables. Busey, in the meantime, continued to engage the first bandit in conversation in hopes of learning anything that might later help in identifying him. This even included an invitation to join them for dinner that the bandit politely declined. From the conversation, Busey learned little other than the man was well spoken, which indicated the bandit had some education.

The hostess, Kate Baker Busey.
Courtesy Champaign County Archives of the Urbana Free Library.

The second bandit returned to report that he had found nothing of value. The first bandit found this hard to believe. In fact, there were valuables in the home—fine furniture, and other furnishings and artifacts—collected by this prosperous family over the years, just nothing that was easily portable. "This is a pretty swell dump not to have anything in it," commented the lead bandit. Busey sought to explain that he was a banker and he did not make it a practice to keep valuables around the house.

In backing out the door, the Buseys were warned not to be too hasty in sounding the alarm. No automobile was heard leaving. Busey immediately called the police, but the bandits were not apprehended. Busey was convinced that the men were strangers and had no idea whose home they were robbing. Later, in examining the upstairs, Mrs. Busey found the only item of value missing was a diamond-studded Daughters of the American Revolution (DAR) pin, which was duly reported to the insurance company. Many years later, the pin was found in the closet where it had dropped as the robber

rummaged through Mrs. Busey's belongings; Mr. Busey called his insurance agent to report the find. According to Garreta, the agent advised Mr. Busey, "By all means, please don't mention it; it will create more problems than it is worth for the company."

THE HARRIS HEIST

Less than a year later, a far more spectacular robbery occurred in Champaign at the baronial mansion of Henry Hickman Harris II, scion of another prominent county banking family. The home had been built by his father, Benjamin Franklin Harris II, and it remains the most extravagant private residence ever built in Champaign County. Son Henry, it seems, was more playboy than serious businessman and was kept out of the management of the family banking business.

It was the evening following the Illinois–Army football game with huge crowds in town. Henry was throwing a large party to which almost everybody who was anybody was invited. Shortly after 10:30 Saturday evening, a car drove up that contained a driver and four men. The driver stayed in the car while the others invaded the home. The many guests were held at gunpoint and systematically relieved of their cash and jewels. Unbeknownst to the robbers, however, one of the guests managed to slip away and call the police.

Either thinking the call to be a joke or wildly underestimating the seriousness of the call, only two patrolmen responded. But undermanned as they were, the two officers made a good accounting for themselves. Officer Gilbert Brown surprised one of the thieves, disarmed him and put him in handcuffs. About that time shots were heard. Brown found the second officer—the future chief Clyde Davis—struggling with another one of the thieves. Brown delivered a blow to the head of the bandit, who tumbled down the stairs. Regaining his feet, he began to flee only to have Brown fire two shots in his direction. One found its mark and the man died two days later at Burnham Hospital. The driver of the getaway car and the remaining bandits managed to flee with a good-sized haul.

In the Harris robbery, the thieves knew exactly whose home they were robbing. Given the reported take, the party was clearly a great target. The one robber who was arrested managed to escape only to be arrested again in the pursuit of his profession. The other three were later apprehended, one in Decatur and the other two in California. Of particular interest to me was

The Harris mansion. *Courtesy Champaign County Archives of the Urbana Free Library.*

the presence of a band member, young saxophone player Virgil Lafferty. He later served as mayor of Champaign, some six mayors prior to me.

The Laffertys lived a few blocks east of my folks, and I went to school with their oldest son, Dean. I had a chance to talk with my predecessor before he died and ask him what it was like during the holdup. As I recall he said that he was "damn scared." In a later conversation with son Dean, he said his father recalled that one of the bandits approached the band and told them: "'Play and play loud and fast,' and we did and none of us played the same tune!"

333 US 203

A Law Case

Few people would have guessed in the spring of 1940 that the simple suggestion of Champaign schools superintendent Vernon L. Nickell recommending a program of religious education involving the public schools would result in a protracted legal battle and landmark decision by the United States Supreme Court.

Vashti McCollum
on March 8, 1948.
Courtesy News-Gazette.

In his outline of the proposed program, Nickell said it would be voluntary and students who wanted the instruction could leave on school time for one hour each week to attend "services or other activity at the church of their choice." Nickell explained that "similar weekly dismissals of students for church activity [had] been tried successfully in other cities." The program, Nickell said, "would be in keeping with the work of the new community committee on child delinquency." Sensing the legal sensitivity of his proposal, the superintendent continued: "It is certain that the youth of the community needs additional instruction in the spiritual side, which we, by law, are prohibited from giving in the school system."

The school board directed Nickell to look into the feasibility of such a program. A committee of the Champaign and Urbana ministerial associations worked through the summer with unnamed school officials. A young Presbyterian minister, A. Ray Cartlidge, was selected to lead the effort. During this time, Arthur G. Cromwell, of Rochester, New York,

happened to be in town visiting his daughter, a young housewife and mother, Vashti Cromwell McCollum. Alerted by press coverage, he chose to attend and protest the proposed classes. Nevertheless, the planning continued; by fall the classes were in place and offered at the junior high level. There was one change; organizers recognized transportation problems of using the churches so the classes were held in the public schools. Originally there were three classes: Protestant (on a one-size-fits-all basis), Catholic and Jewish. Participation of Jewish students ended early on.

In subsequent years, the classes were expanded to the elementary level. In 1944, they reached the fourth grade and James Terry McCollum, the son of young mother Vashti McCollum. Terry and his classmates received a permission slip to take home for parental consent and a choice of which religious class the child would attend. Terry's family was opposed to the classes and refused to sign the slip. Most of his classmates subscribed to the Protestant classes so Terry was asked to leave the room for the period of religious instruction. This immediately set him apart from his fellows. Inevitably, this led to trouble for Terry.

Terry's problems in school came home and Mrs. McCollum visited school officials to complain. School superintendent Eugene Mellon listened politely to the young matron's story but indicated that the classes represented board policy and there was nothing that he personally could do. (Nickell by then had moved on to become state superintendent of public instruction.) As problems worsened for Terry, his mother got in contact with the local Unitarian minister, Philip Schug, for help. He knew of a group in Chicago interested in challenging the practice of "released time" in public schools for religious instruction.

The group, the Chicago Action Council, was quick to offer help and provided a lawyer if the case went to court. On Monday, June 11, 1945, Mrs. McCollum filed a petition for writ of mandamus in the circuit court of Champaign County demanding that the Champaign Board of Education be ordered to end the religious education classes. The story was immediately major news locally and very quickly became national news, something the then naive young mother was hardly prepared for.

Mrs. McCollum, the plaintiff, was focused on the narrow proposition that the religious classes in the public schools on school time violated the First Amendment: "Congress shall make no law respecting an establishment of religion, or prohibiting the free exercise thereof..." as applied to the state by the due process clause of the Fourteenth Amendment. Her Chicago attorney had different ideas, picturing himself as a latter-day Clarence Darrow. The

thrust of his pleadings made it appear that the intention was to wage a war against religion in general.

If the filing of the case raised a stir, the weeklong trial beginning on September 10, 1945, was earthshaking. All the major Chicago newspapers sent reporters and the wire services carried blow by blow accounts nationwide. A Chicago legal firm was hired by outside interests on behalf of the defendant school district in the possible event that either the board's attorney was not up to the job or the district might not wish to finance the case beyond the circuit court level. In the case of the former, the Chicagoans quickly discovered that the local attorney, John Franklin, was more than up to the job.

On the first day of the trial, a young man approached Superintendent Mellon and stated that he had come "to testify for the Lord." Mellon, a courtly individual, directed the young man to Franklin, who was standing nearby. After hearing the man's proposal, the tall Lincolnesque attorney said, "The Lord is not on trial here today." Franklin's response did accurately state the case, but the plaintiff's attorney conducted the trial in a way that would strongly suggest that the Lord was in fact on trial.

One Chicago reporter, weak on historical facts, reported that the Urbana courthouse was the site of one of the historic Lincoln–Douglas debates. After the first day's proceedings, another reporter noted: "The test case [the plaintiff] inspired has turned the eyes of the nation on this red-bricked courthouse." The plaintiff was variously described as "a crusading liberal," "looking like a coed" and "small, dark and vivid" with "snapping eyes."

The Chicago Action Council was alarmed at the bad publicity generated by the approach of their attorney and considered withdrawing their support of the case. The plaintiff, who was also deeply dissatisfied with the antireligious approach, and with the members of the council forced a new direction to the case, but the damage for the most part had been done.

At the end of the trial, the three-judge panel hearing the case required briefs before they were prepared to render a ruling. Delays in filing the briefs and the slow workings of the court system delayed the decision for over five months. The ruling sustained the defendant school district's contention that the religious classes were legal. An appeal was quickly taken to the Illinois Supreme Court, this time with a new attorney, Walter Dodd. Every effort was made to concentrate on the legal issues and abandon the antireligious tone interjected by the trial attorney. On November 20, 1946, oral arguments were heard by the court. On January 20, 1947, the Illinois Supreme Court affirmed the decision of the circuit court.

By this point, the plaintiff had more than established herself as the prime force in her case. With the adverse decisions in the state courts, the only alternative left was an appeal to the United States Supreme Court. The high court hears only a small percentage of the cases presented to it; but this case was one of them. The plaintiff went to Washington to hear the oral arguments on December 8, 1947. On March 8, 1948, the plaintiff was awakened by a call from a *Courier* reporter informing her that she had won her case with an 8–1 ruling.

The result was described as landmark decision in that it was the first case under the establishment of religion clause where actions of a local level of government were determined to have violated the First and Fourteenth Amendments to the Constitution. The notoriety associated with the case made the plaintiff a minor celebrity. She wrote a book about her case, *One Woman's Fight*, and for several years was active in church–state issues. She then went on with the rest of her life, all ninety-three years of it. For my part, as the younger brother, I was the young fly on the wall for *McCollum v. Board of Education*.

ELM TREES AND BEETLES

I was a sophomore in high school when I first became aware of a large-scale effort to control an insect pest. The offending critter was the elm bark beetle; the year was 1951; and the shade tree of choice in the newer areas of Champaign and on the university campus was the American elm. These trees spanned gracefully over the streets like Gothic arches. The beetle was the vector of a fatal disease to elm trees and it had hit the twin cities with a vengeance. The strategy was to take down diseased trees as quickly as possible and spray the town regularly to protect the healthy trees that remained.

A scant three years later, a much more serious pest was discovered in east-central Illinois—the Japanese beetle known to scientists as *Popillia japonica*. First discovered in 1916 in New Jersey, these nonnative creatures had a voracious appetite for a wide variety of agricultural and ornamental plants and no natural enemies. In spite of quarantine efforts, the infestation spread.

Both pest outbreaks in the area occurred after World War II. During the war, powerful new chemicals had been formulated—the best known being DDT—to fight insect pests. Armed with these compounds, many entomologists felt that they had the answer to mosquitoes, elm bark and Japanese beetles and about any other problem insect one could think of.

The Human Side of Place

With the cooperation of the State of Illinois, the United States Department of Agriculture was determined to eliminate the infestation of Japanese beetles using broad applications of insecticides. The original area of infestation was about 10,000 acres near the town of Sheldon. In 1954, 1,535 acres were treated. By 1958, the treated area had grown to 17,844 acres.

Everything within the control area was treated: farms, houses, streams, roads and the towns of Sheldon and Effner. Ultimately, over 100,000 acres were treated with two insecticides, Dieldren and Aldren. The strategy was to broadcast heavy applications—three pounds per acre—of the insecticide. Both were related to DDT in a family of chemicals known as chlorinated hydrocarbons.

William Luckmann.
Courtesy Illinois
Natural History Survey.

During the summer of 1955, when I needed a summer job between my freshman and sophomore years in college, my father suggested I see Dr. William Luckmann, an entomologist at the State of Illinois Natural History Survey. It was an agency affiliated with the university. I was assigned to the summer crew of the economic entomology section under Luckmann's supervision.

At first I worked summers, then, after graduation, full time. Among my tasks was to assist in the collection of data in the Japanese treatment area. In 1960, Luckmann published the results of the early eradication efforts, which indicated that initially the control program was highly effective in controlling the developing beetle grubs in the soil. But Luckmann also noted some unintended results: some farm animals had died, others became sick; household cats allowed to roam outside were practically eliminated; and concentrations of the pesticides were found in the milk of cows that grazed in pastures that had been treated.

Sometime following publication of the article, Luckmann received a postcard requesting a reprint of his study. The card was signed by a then relatively unknown marine biologist named Rachael Carson. Ms. Carson contacted Dr. Thomas Scott, also of the natural history survey, about the section dealing with wildlife research. Scott's study revealed that the treatments had serious consequences to wildlife, especially birds and small mammals.

Carson's seminal work, *Silent Spring*, appeared in 1962. In the chapter "And No Birds Sang," Carson discussed the results of the Japanese eradication efforts. I remember the consternation expressed by some of the older entomologists for whom I worked; they felt personally threatened by Carson's conclusions relating to the evils of an indiscriminate use of pesticides. The younger generation, Luckmann included, quickly realized that the easy answer approach was gone forever and shifted to a more balanced approach to insect pest control that included reducing the use of pesticides, using biological controls and more imaginative agricultural techniques.

About the time Rachael Carson's book appeared, I found through samples of the treatment area that Japanese beetle grubs were alive and well in the treated areas, which indicated that either the success of the treatments of the highly stable insecticides had dissipated over time or the beetles had developed some level of resistance. The eradication effort had been a failure. Carson, battling cancer as she worked on her book, died two years after the publication of *Silent Spring*. She did live long enough to see the controversy generated by the book, but not long enough to see her ideas widely accepted.

The elm bark beetles also fared better than the American elm trees; within a decade of the first appearance of the disease, all of those wonderful trees that had gracefully arched across the streets of Champaign–Urbana were gone. As Rachael Carson had warned, chemical answers to such problems have serious environmental downsides. As time has shown again and again, there are no easy solutions to serious problems.

DEATH OF A NEWSPAPER

For about a year before the *Courier* ceased publication, I wrote a weekly column called "Conservation." My relationship with the newspaper far predated that final day in 1978. For several years in the late'40s and early '50s, I delivered the *Courier* in a ten-square-block area of what was then central Champaign, from Green to Springfield (both sides) and from

The *Courier* building. *Courtesy Champaign County Archives of the Urbana Free Library.*

Prospect to Prairie. I had also been a friend and admirer of longtime *Courier* editor Robert Sink.

With the dissolution of the Lindsey-Schaub newspaper chain, the *Courier* had not been marketable, and it was announced that the last issue of the newspaper would be March 31, 1979. I resolved to be present for the entire day, from start to finish of the press run. Almost immediately, I noticed the emotional differences between the editorial staff and the people who worked the shop and press. It seemed that to the latter, the *Courier* was just a job, albeit one that would soon end. For the editorial people, the attachment was personal; that last day was the most animate—but at the same time inanimate—death I have ever witnessed. On the front page under the headline "Parting Words" was a comment by reporter Carrie Muskat that seemed to sum things up: "I cried the last four months, I don't have time to be hysterical now; I have two stories to write."

The antique rotary press was temperamental and occasionally failed to operate. On such occasions, the paper had to be sent to Decatur to be printed. When at last the paper was ready to be run off, Publisher Jerry Denning walked over to the iron monster of a press, kicked it and said,

The goodbye headline by the *Courier* on March 31, 1979.

"Don't you quit, you son of a bitch." Virtually all of the editorial staff—yours truly included—stood around and sadly watched while the final edition was printed.

When the last press run was done, Curt Beamer, photographer extraordinaire, grabbed a young apprentice and dragged him over to what remained on the paper roll, pulled down two feet of blank paper and with a magic marker wrote "The End." To the apprentice, he said, "That's your picture."

MARCH MADNESS

The Final Four

The 1988–89 basketball season brought Coach Lew Henson's finest team at the University of Illinois. Not only did it win the conference title, it played its way into the final four. On the eighth of March, I received a call from Rich Cahan of the *Chicago Sun-Times,* formerly of the *Morning Courier,* requesting my assistance in providing a vintage automobile—preferably a Model T Ford—so that a photographer from the Big City could take a picture of a number of the Illini players in, on or around the car as part of their sports coverage.

The only person I knew who had a collection of cars that would include a suitable vehicle was local restaurateur Alan Strong. Alan, whose collection consisted largely of vintage Packards and other princely cars of the late twenties and early thirties, had no Model Ts but offered to bring a similar car from his collection. The following day was clear and perfect for photography. Alan drove into the Assembly Hall parking lot in a 1932 Chrysler Phaeton touring car. A Model T this car was not—this was a big automobile! Out came three of the star players in game uniforms to drape themselves around the car. These guys were very large and well proportioned—superb athletes. Once positioned in and on the car, the vehicle, which I initially expected to dwarf the players, by contrast was itself dwarfed!

My involvement with the basketball business was unfortunately not over. On the Wednesday prior to the semifinal game with Michigan on March 29, I received a call from Mayor Jerry Jenerigan of Ann Arbor, home of the mighty Wolverines. He was interested in making a wager regarding the outcome of the contest. After some discussion, we agreed that the mayor of the losing team's city would fly the flag of the winning team at their city

hall. It all seemed like fun and I was bolstered that the fact that the Illini had beaten the Wolverines twice during the regular season.

The wager was immediately picked up by the media. The *News-Gazette*, in a story the following day, reported the wager, commenting, "Both Mayors are feeling confident, although McCollum, known better for his scholarly endeavors, admitted he's not the biggest Illini fan in town." When asked by the university Athletic Department what size of flag they should prepare, I said, "a damn big one." I was not the only politician drawn into the contest. My friend and U.S. senator, Paul Simon, wagered a case of Orange Crush, a soft drink that carried the name of a student cheering section, against a case of ginger ale put up by Michigan senator Carl Levin. I sent a letter to Coach Henson and the team wishing them luck and reminding them that the honor of the city rested in their hands. I wanted to provide as much encouragement as possible.

My wife and I had been out for the evening the night of the big game. When we returned, I thought to turn on the radio to see whether I had won or lost the wager. I got the last few minutes of the game, which in the closing seconds the Fighting Illini managed to lose. I said to Jeanie, "here come the phone calls," and almost immediately they did. The first suggested that I fly the Michigan flag upside down; a second following within minutes suggested that it fly at half-mast. And there were other calls that evening and in the several days that followed, all negative. But for me, a deal is a deal; I intended that the flag would go up properly.

The Wednesday following the game was set as flag-raising day. It had to be postponed for a day to await the arrival of the flag from Ann Arbor. The media was on hand for the event along with a number of bystanders. I did not feel that it was appropriate for city staff to do the deed so I stepped up to the pole. As I was attaching the flag, a fairly nice car pulled up, an attractive woman stuck her head out and hollered out an obscenity in my direction. I must admit that I had a hard time understanding people taking an athletic rivalry so seriously. But for my own piece of mind, should a similar occasion arise in the future, I was done making such wagers.

Bibliography

Baker, Willis and Patricia Miller. *A Commemorative History of Champaign County, Illinois: 1833-1983*. Champaign: Illinois Heritage Association, 1984.

Beckwith, Hiram. *History of Vermilion County*. Chicago: H.H. Hill, 1879.

Bogue, Allan G. *From Prairie to Cornbelt*. Chicago: Quadrangle Books, 1963.

Brink and McDonough, *History of Champaign County, 1878*. N.p.: n.d.

Busey, Garreta. *The Windbreak*. New York: Funk & Wagnalls, 1938.

Busey, George W. Autobiography. Busey Family Collection.

City of Champaign Staff, *2006 Downtown Plan*. 2006.

Corliss, Carlton J. *Main Line of Mid-America*. New York: Creative Age Press, 1950.

Cunningham, J.O. *The History of Champaign County, 1905*. Champaign County Historical Archives, reprint, 1984.

Harris, B.F. Autobiography, unpublished. Champaign County Archives of the Urbana Free Library.

Kacich, Thomas. *Hot Type*. Champaign, IL: Sports Publishing, 2002.

Lothrop, J.S. *Champaign County Directory 1870–1 with History of the Same*. Chicago: Rand McNally, 1871.

McCollum, Dannel. *Essays on the Historical Geography of Champaign County*. Champaign, IL: Champaign County Historical Museum, 2005.

3M. *The Lord Was Not On Trial*. Silver Spring, MD: Americans For Religious Liberty, 2008.

Stewart, J.R. *A Standard History of Champaign County Illinois*. Chicago: Lewis, 1918.

About the Author

Dannel McCollum is a native of Champaign County. In his various life experiences, he has been an army officer, research assistant with the Illinois Natural History Survey, high school teacher, conservationist, activist, local historian, writer and politician, having served three terms as mayor of Champaign (1987–1999). As a writer, Dan has written for numerous area newspapers, historical journals and educational magazines. His other books include *Your Life and Mine*; *Problems and Projects in Conservation*, *A Guide to the Big Vermilion River System* with James O. Smith, *Essays on the Historical Geography of Champaign County* and *The Lord Was Not on Trial*.

Visit us at
www.historypress.net